Beaufort

SOUTH CAROLINA

Beaufort

SOUTH CAROLINA

Pages from the Past

Gerhard Spieler

with the Beaufort County Historical Society

THE
History
PRESS

Published by The History Press
Charleston, SC 29403
www.historypress.net

Cover design by Natasha Momberger.
All images are courtesy of the Beaufort County Historical Society.

First published 2008

Manufactured in the United States

ISBN 978.1.59629.428.8

Library of Congress Cataloging-in-Publication Data

Spieler, Gerhard.
Beaufort, South Carolina : pages from the past / Gerhard Spieler.
p. cm.
ISBN 978-1-59629-428-8
1. Beaufort (S.C.)--History. 2. Beaufort (S.C.)--Biography. I. Title.
F279.B3S645 2008
975.7'99--dc22
2008003256

*Dedicated with love and affection to my wife
and helpmate Ruth de Treville Spieler*

CONTENTS

FOREWORD

Gerhard Spieler's work on the history of Beaufort County has spanned more than four decades. Born in Germany on June 23, 1920, he arrived in New York with his mother in June 1930 to reunite with his father who had come to the United States several years earlier. He served in the United States Army in World War II and eventually settled in Beaufort, South Carolina, where he worked for the Beaufort County government. He began assembling his own collection of artifacts and archival material in the 1960s and has never stopped. In 1976, he married Ruth de Treville and together they live in the historic de Treville House in downtown Beaufort. In the 1970s he began sharing his vast knowledge of Beaufort's history with the general public through a weekly column for the *Beaufort Gazette*. He also wrote in-depth articles published in the Greater Beaufort Chamber of Commerce magazine. What follows in this book is a small sample of Gerhard Spieler's large body of work on local history taken from this magazine, appropriately named *Beaufort! Land of Isles*.

The articles included here were selected by the author himself, meticulously compiled and organized by historian Dr. Stephen R. Wise and his wife Alice and published by The History Press of Charleston for the Beaufort County Historical Society. Some of the articles presented here have never been previously published, and others have not been in print for more than twenty-five years. Some of the scholarship in this book is entirely original and not available in any other publication. Other articles are based on scholarship gleaned from careful reading of long-forgotten secondary sources. Together they represent an excellent introduction to the history of one of the oldest communities in America.

The articles presented here span five centuries of history. From the earliest Spanish voyages of the sixteenth century, through the bloody Indian wars and colonial settlement of the eighteenth century to the spectacular rise and dramatic fall of the fabled Sea Island cotton kingdom in the nineteenth century, Gerhard Spieler's writings are, indeed, priceless *Pages from the Past.*

Lawrence S. Rowland
Distinguished Professor Emeritus
University of South Carolina–Beaufort

Gerhard Spieler is an amazing individual to have acquired the knowledge and understanding that he has displayed over the years in his many articles. And not just knowledge of events that have taken place in South Carolina, but also of individuals and emotions that have been part of the history of the Lowcountry. He is widely respected for the range of his subjects and for the hundreds of stories that he has produced in the *Beaufort Gazette* and in the *Land of Isles* magazine. He is the Ernest Hemingway of Carolina's coastal areas.

Charles Stockell
Publisher of the *Land of Isles* magazine

THE PRIZE
OF SANTA ELENA

It is fitting that in January 1942 Howard and Ruby C. Danner stated:

> *For two hundred and forty years, covering a period from 1520, when the first expedition set sail, to 1763 when Spain finally relinquished all claim to this region to the English, Santa Elena was but a part of the American stake in the contest for which Spain, France, and England employed every wile of diplomatic intrigue and every device of border warfare.*

The Spaniards wished to possess this area in order to safeguard their homeward-bound treasure ships. They also wished to expand their American possessions northward. The French wanted the same area so that they would be in a good position to attack Spanish ships loaded with precious merchandise from Mexico and South America. They also saw in the region a possible refuge for the Huguenot religious minority. The English, who were relative newcomers, desired the land to reward noblemen who had remained faithful to the monarchy during Cromwell's reign and to settle Englishmen on it.

There are indications that Spanish seafarers reached the Carolina coast even before the first voyage of historical record in 1521. It was in this year that Francisco Gordillo first came to this area at the behest of Lucas Vásquez de Ayllón, a high government official of Santo Domingo. On the voyage, a relative, Pedro de Quexo, joined him. According to Spanish historian Barcia, Gordillo "disembarked in several parts, especially in Chicora," in 1521.

S. Salley Jr. and Dr. Mary Ross, both historians, identified Cape Santa Elena as the easternmost projection of present-day St. Helena Island. Other

authorities believed the cape to have been the northeast point of Hilton Head Island; however, now most historians identify the Point of Santa Elena, the Spanish name being "Punta de Santa Elena," as Tybee Island, Georgia.

Although Gordillo had been instructed not to take any slaves, he and Quexo enticed several hundred Native Americans of the Chicora area onboard their ships and sailed for home. Encountering storms, many of the Native Americans died—only about 130 reached Santo Domingo, where Ayllón had most of them freed and carried back to their native land.

Early in 1525, Ayllón sent Quexo back to Santa Elena with two caravels. Stone markers to claim the land for Spain were set up, and by July of that year Quexo had returned to Santo Domingo. In June 1526, Ayllón, by virtue of his royal grant, sailed from Puerto de la Plata with six hundred people, as well as livestock, onboard three ships. Reaching the estuary of a large river, one of the ships was lost. The Spanish quickly built another—"probably the first instance of ship-building on this coast."

According to the Danners, whose 1942 account was the first detailed study of Spanish exploration and settlement in the Santa Elena area, the weight of historical evidence indicated that Ayllón then sailed to the South, landing

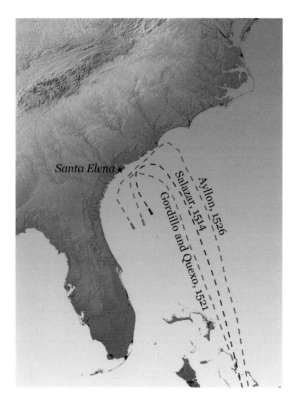

Early Spanish voyages along the southeastern coast of the United States.

in the vicinity of Santa Elena, where he planted his colony, naming it "San Miguel de Gualdape." Some historians place this settlement at Winyah Bay, near Georgetown, but its actual location was more likely to have been in the present-day Beaufort area.

A letter from Don Luis de Velasco to King Philip II of Spain supported the opinion that the settlement of San Miguel de Gualdape was in the Beaufort County region. Writing from Mexico on September 30, 1558, Velasco stated:

> *There is no certainty in which location Santa Elena is, other than what the people say who were with De Soto that they came upon a river which the Indians told them was the River of Pearls and that they were three days journey from the sea. This river is the one which flows into the sea near Punta de Santa Elena.*

The Savannah River fits that description.

In 1524, Stephen Gomez was sent by Charles V of Spain to search for a waterway from the Atlantic to the Indies. Sailing along the North American coast as far as New England, Gomez retraced his course, exploring the South Atlantic coastline of the New World.

In his history of Florida, Barcia reported that a Spanish fleet under Farfan was wrecked at Cape Santa Elena in December of 1554, emphasizing the importance of outposts to aid wrecked Spanish mariners, as well as a possible overland route from Mexico, or the Gulf of Mexico, to the Atlantic Ocean.

In 1557, Philip II of Spain ordered colonization of Florida at two points, one of which was Santa Elena, directing:

> *That the colonists were not to conquer those nations, nor to do what had been done in the discovery of the Indies, but to settle, and by good example, with good works and with presents, to bring them to a knowledge of our Holy Faith and Catholic Truth.*

Despite repeated royal commands to settle at Santa Elena, there was a definite reluctance to do so by several Spanish expedition leaders. On December 29, 1557, Philip II wrote: "We are sending orders to Don Luis de Velasco, our viceroy of that country, that he is to provide for making a settlement on the Point of Santa Elena, which is in Florida."

In 1558, Velasco sent Guido de Las Bazares to examine the harbor of Santa Elena and select a site for settlement. Storms prevented his rounding the southern tip of Florida, and Las Bazares ended up in Pensacola Bay, in the Gulf

of Mexico. About that time, Tristán de Luna y Arellano was named captain general of the fleet and governor of "La Florida and the Punta de Santa Elena."

In 1559, Philip II again commanded Luna to settle at Santa Elena for the purpose of checkmating similar French attempts. On August 10, 1559, Luna went with a party of about a hundred men to do so. That venture failed also because of storms and shipwreck. Ángel de Villafañe replaced Luna. Most of the Pensacola settlers by that time were glad to volunteer to accompany Villafañe to Santa Elena. The expedition claimed to have arrived on May 27, 1561, but it is believed that their landfall was in Georgia. Claiming the area unsuited for settlement, as well as lacking a safe harbor, Villafañe abandoned the venture after having taken formal possession of the coastal area for the king of Spain.

Discouraged by these repeated failures, and upon being advised that the French were not likely to either settle or garrison that area, on September 23, 1561, Philip II decided that no further attempt should be made to locate a settlement or base at Santa Elena.

FRENCH CLAIMS TO FLORIDA

The French had their own historic claims to Florida, which, in the eighteenth century, included most of the Eastern seaboard of the present-day United States up to and including Virginia. Both the French crown and the Huguenots under Admiral Gaspard de Coligny hoped that French settlers in Florida would help lessen religious tensions at home and strengthen France's position in the New World. The French also hoped that by settling in an area in which Philip II had decided not to settle, an open confrontation with the Spanish might be avoided.

David L. Dowd, in the introduction to the quadricentennial edition of Jean Ribaut's *The Whole and True Discovery of Terra Florida*, wrote:

> *Challenged by Spain, Catherine de Medici had to defend her subjects in Florida or disavow them. At first she temporized, hoping that the Turkish threat would monopolize Philip's attention. In November 1565, Catherine was insisting that the French had gone to Florida legitimately because that land had belonged to France for a long time. She identified it with the Nova Scotia area frequented by French fishermen since the beginning of the sixteenth century and claimed long since for France by Verrazano and Cartier.*

Jean Ribaut, in his personal account of his discoveries, ignored Spanish explorations altogether and only mentioned Sebastian Cabot's voyage for Henry VII of England as a failure. He wrote:

> There was one a very famous stranger Sebastian Cabot, an excellent pilot, sent thither by the King of England, Henry, the VII and many others, who never could attain to any habitation or take possession there of one only foot of ground,…the living God hath reserved this great land for the King's poor subjects, as well to the end they might be made great over this poor people and rude nation, as also to approve the former affection which our King Francis, of happy memory, a prince wit excellent virtues, anno 1524, sent a famous and notable man, a Florentine named Messer Jehan de Verrazano to search and Discover e west parts as far as might be,… where he found e elevation of the pole of 38 degrees, e country, as he wrote, goodly, fruitful, and of so good a temperance as it not possible o have better, being then as yet of no man seen, nor discovered.

Verrazano's exploration of the South Atlantic coastline in 1524 has been mentioned only briefly in most histories. Samuel Eliot Morison, in *The European Discovery of America*, supposes landfall at Cape Fear, North Carolina, and then a southward trip for "fifty leagues," turning north again "in order not to meet with the Spaniards." Morison then writes that, "since he had not found any convenient harbor whereby to come a-land, the turning point must have been short of Charleston."

Using the navigation instruments of his day, Verrazano estimated his landfall at latitude 34° north, which would be near Cape Fear. Morison and most historians assumed a league, as used by Verrazano, to be the French measurement equivalent to about 2.3 miles, but Verrazano's brother Giralamo, a mapmaker who was along on the voyage, used a scale of 3.2 miles to the league. Using this latter measure of distance would place Verrazano not north of Charleston, but right off Parris or Hunting Islands.

The description of the New World by Verrazano would match that of the local coast:

> The maritime shore is all covered with fine sand fifteen feet high, extending in the form of little hills about fifty paces wide. After going ahead, some rivers and arms of the sea were found which enter through some mouths, coursing the shore on both sides as it follows its windings. Nearby appears the spacious land, so high that it exceeds the sandy shore, with many beautiful fields and plains, full of the largest forests, some thin and some

dense. And do not believe, Your Majesty, that these are like the…northern countries, full of rugged trees, but adorned and clothed with palms, laurels, and cypresses, and other varieties of trees unknown in our Europe.

Jean Ribaut first touched land on April 30, 1562, on the east coast of Florida, which he named Cap François, probably at or near Matanzas Inlet. He then sailed north, discovering and naming rivers and inlets. Of all those French names, only Port Royal and Port Royal Sound have survived. On May 22, 1562, Ribaut placed a stone column on one of the islands in Port Royal Sound, claiming the land for the French king. Before sailing back to France, Ribaut had a fort with a small garrison built on Parris Island. He left on June 11, 1562. He described the location of the fort as "in an island on the northeast side, a place of strong situation and commodious, upon a river which we have called Chenonceau and the inhabitation and fortress Charlesforte."

René de Laudonnière had accompanied Jean Ribaut on his first voyage in 1562. He wrote that Ribaut's expedition "was so well furnished with gentlemen (of whose number I myself was one) and with old soldiers, that he had means to achieve some notable thing and worthy of eternal memory." In 1564, Laudonnière was sent by Admiral Coligny to attempt a second

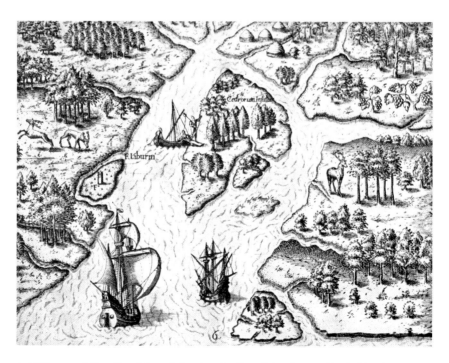

A 1562 map of Port Royal Sound showing the French landing on Parris Island.

settlement in Florida. That was to be Fort Caroline, near the mouth of the Saint Johns River. Laudonnière sent some of his men to Port Royal to renew friendly relations with the Native Americans. He had decided, however, not to settle there again:

> We would not find it very comfortable or usable, at least if we were to believe the reports of those who had lived there for a long time. Although the harbor there was one of the finest in the West Indies, the issue was not so much a question of the beauty of the location but more a question of the availability of things necessary to sustain daily life.

By the end of August, provisions were running short at Fort Caroline, but on August 28, 1565, Jean Ribaut arrived with a fleet of seven ships from France. Scarcely a week later, after Jean Ribaut had departed with a strong force southward, the Spaniards came by land and surprised and captured Fort Caroline, killing most of the garrison. After being shipwrecked, Jean Ribaut and his soldiers met their end at Matanzas, where they were massacred by the Spaniards. René de Laudonnière, however, escaped to one of the few surviving French ships and returned to France.

The loss of Fort Caroline, and more importantly, Captain Jean Ribaut, was not the end of French attempts to establish themselves in Florida. In 1577, Nicolas Strozzi, a Florentine and a relative of Catherine de Medici, was shipwrecked, but he managed to build a third French fort on an island near the mouth of the Edisto River, some twenty miles north of the old Charlesfort. Native Americans overran the fort, and Pedro Menéndez Marqués, the successor of Pedro Menéndez de Avilés, killed the survivors. French ships continued to frequent the area, sufficiently strong in numbers to engage Spanish fleets in 1596 and in 1603. Other French ships were sighted in the Savannah River in 1605.

COMING OF THE ENGLISH

English claims to the land were based on the explorations of John and Sebastian Cabot. In the words of Robert Sandford from *Relation of a Voyage* (1666):

> In prosecution of his sacred Majesty's pious intentions of planting and civilizing those his towns and people of the northern America, which neighbour southward on Virginia (by some called Florida) found out

and discovered by Sr. Sebastian Cabott in the year 1497 at the charges of Henry VII, King of England.

An old history said of John Cabot and his son Sebastian:

In April, 1498, they sailed again from Bristol; on this voyage John died and Sebastian succeeded to the command. The place of the landfall is uncertain; probably Labrador and Prince Edward Island were reached… leaving that island [Newfoundland], *he coasted as far as the shores of Maine, and, some writers think, as far south as the Carolinas.*

Nothing came of the first grant of land in the Carolinas by Charles I to his attorney general Sir Robert Heath in 1629. On March 20, 1663, Charles II granted the land from latitude 31° to 36° north to eight Lords Proprietors. This land was extended in 1665 from latitude 29° to 36° 30' north. In 1663, Captain William Hilton was engaged by planters from Barbados to explore the land from Cape Fear to latitude 31° north. At the same time, the planters negotiated with the Lords Proprietors for a thousand-square-mile tract of land and a certain amount of self-government.

William Hilton sighted land on August 26, 1663:

On the coast of Florida, in the latitude of 32 degrees 30 minutes being four leagues or thereabouts to the Northwards of Saint Ellens… On Tuesday the third we entered the harbor, and found that it was the River Jordan [probably the Combahee], *and was but four leagues or thereabouts N.E. from Port Royal, which by the Spanyards is called St. Ellens, within land, both rivers meet in one.*

Later, Hilton wrote that "the air is clear and sweet, the country very pleasant and delightful: and we would wish, that all they that want a happy settlement, of our English Nation, were well transported thither."

In 1666, Captain Robert Sandford explored the Carolina coast "from the Charles River near Cape Fear, to Port Royall, in the North Lat. of 32 Deg; begun 14th June, 1666" on behalf of the "Lords Proprietors of their County of Clarendon." His description of Port Royal Sound was as follows:

The morning was calm, and so continued till about two o'clock afternoon, when a fresh gale sprang up at North East, which in a short time opened to us Woory Bay and the mouth of Port Royall. Woory

Bay, of Lt. Woory, is made by the South Westerly end of Cary Island, and the Southermost cape or head land without Port Royall, called from the first discoverer Hilton Head.

Sandford visited a nearby Native American town, "at the end of which stood a fair wooden cross of the Spaniards' erection."

Encouraged by favorable reports, the Lords Proprietors dispatched the first colonists with instructions to settle at Port Royal. One of the instructions read:

When you arrive at Port Royall you are in some convenient place on one side of the towne, & where it may be least inconvenient to the people, to take up as much land for our uses as our properties will come at 150 acres per head of 30 servants, and in your land let there be some marsh, and not much, the rest to be of as many varieties of soil as may be.

Like the first Spanish attempts to settle at Santa Elena, the first English attempt failed as well. The colonists did land at Port Royal, but after a brief stay they removed farther north.

It would be another thirty years before the first settlers would come in numbers to the Port Royal area. The town of Beaufort would be chartered in 1710–11. Despite Spanish and French attacks and Indian wars, the English settlements would prosper. In 1763, Spain would finally relinquish her claim to Santa Elena and the province of Chicora.

PEDRO MENÉNDEZ
DE AVILÉS

There are history books of South Carolina that commence with the coming of the first English settlers in 1670, ignoring the settlements of both the French and Spanish. The importance of the latter is only now beginning to be realized, aided by historical research and archaeological excavations on Parris Island directed by Doctors Stanley South and Chester DePratter of the University of South Carolina's Institute of Archaeology and Anthropology. There also may be Spanish remains in Beaufort County that antedate those of St. Augustine by some forty years. The story of Santa Elena needs telling, and so does that of its founder, Pedro Menéndez de Avilés, Florida's first *adelantado*, or governor. The city of St. Augustine, Florida, honors him more appropriately. There is even an annual outdoor musical drama, *The Cross and the Sword*, performed throughout the summer. Menéndez de Avilés should be remembered as the founder of Spain's northernmost bastion of Florida, Santa Elena and its forts; the first man who sought to convert the Native Americans to Christianity; the governor who sent exploring parties far into the interior of an unknown country; and an empire builder who dreamed of making Santa Elena a base of Spain's New World dominion, stretching from the Atlantic Ocean to the Gulf of Mexico.

Pedro Menéndez de Avilés, the son of a noble, but poor, Asturian family, was born on February 15, 1519. He spent much of his life at sea, fighting the French as well as pirates. At the age of thirty-five, King Charles V appointed him captain general of the Indies fleet. After three voyages to New Spain between 1555 and 1563, he served King Philip II in Flanders and England.

On March 20, 1565, Philip II appointed Menéndez de Avilés *adelantado* of Florida, which at that time extended far north and west of the present boundaries of the state with that name. In return for certain rights and privileges, an annual salary of two thousand ducats and "title to 25 leagues of land," he was to explore and settle Florida, drive out foreign intruders and

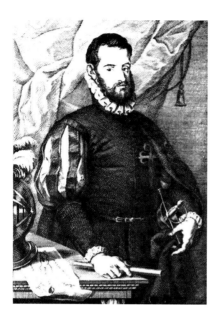

Pedro Menéndez de Avilés, founder of
Santa Elena.

convert the Native Americans to the "True Faith." In a time span of seven years, Menéndez de Avilés would establish forts and settlements on the coast, ranging from Tampa Bay in the Gulf of Mexico to Santa Elena on Parris Island in present-day South Carolina; send a Jesuit mission to Virginia; twice dispatch Captain Juan Pardo into the interior of what would someday be South Carolina and Georgia, establishing posts along the way; preach the faith to Native Americans and seek to convert them; and repel French Huguenot attempts to establish forts at Charlesfort (Port Royal) and Fort Caroline, on the Saint Johns River near the modern city of Jacksonville, Florida.

FIRST VISIT TO SANTA ELENA

Menéndez de Avilés's first visit to Santa Elena in early April of 1566 was described as follows by the Spanish historian Barcia:

> *They set sail for Santa Elena, where they arrived the afternoon of the following day. The Indians knew the port because they were accustomed to fishing thereabouts in their canoes. For a league the ship coursed inland along the estuary until the Indians said it could go no farther, whereupon Menendez anchored and transferred to the brigantines with Esteban de las Alas and a hundred soldiers. After they had sailed two*

leagues, they reached the village of Orista, which had been burned, and where a few Indians were again building some dwellings.

After some initial mistrust on the part of the local Native Americans, they agreed to receive Menéndez de Avilés. Neighboring tribes came and joined the assembly. The Native Americans asked that some Spaniards be left with them to instruct them in Christianity (at least, according to Barcia). A feast was then arranged, described by Barcia as follows:

Presently, many Indian women arrived carrying maize, boiled and roasted fish, oysters, and quantities of acorns. The Adelantado ordered biscuit, wine and honey brought, which he shared with the Indians. The natives drank the wine with great relish and ate the biscuit dipped in honey with even greater enjoyment, for they are very partial to sweets. At the conclusion of the meal, during which there was great mirth and merriment, they seated the Adelantado in the cacique's place, and in the midst of various ceremonies, Orista approached him and took his hands. Then the other caciques and Indians did the same; the mother and relatives of the two slaves brought from Guale caressed him and wept for joy. Afterwards they commenced singing and dancing, while the caciques and some of the Indian chiefs remained with the Adelantado. The celebration and festivities lasted until midnight, at which hour they dispersed to their homes.

In response to the Native Americans' request for some Spaniards to be left with them, "someone to instruct them," Menéndez de Avilés decided to leave a Spanish garrison in the area, but with the advice and help of Orista, the Native American chief. According to Barcia:

The Adelantado told the cacique he was going in search of a good site on which to build a settlement for his Spaniards; they could not live among the Indians, for later they might quarrel. The cacique informed him of a site close to where the ship was anchored. Without any misgiving, he himself embarked, along with his wife and twelve Indians, on the Adelantado's brigantines. All of them proceeded gaily to the spot where they were to go ashore…and the next day they went on to examine the spot for the settlement. All were of the opinion that the site was very fine and pleasant. Without wasting time, the Adelantado, Esteban de las Alas, and other captains marked out the fort; its construction was entrusted to Antonio Gomez…The stockade was built of stakes, earth, and fascines; and six

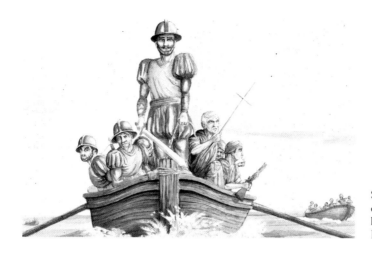

Spanish explorers landing on Parris Island.

bronze pieces were emplaced; The Adelantado named the settlement San Felipe. He appointed Esteban de las Alas as governor of the fort and the territory, and left him one hundred and ten men.

Today, we are agreed that San Felipe was the name given to the fort, while Santa Elena was the name of the settlement or city that grew around it.

Most helpful to the Spaniards in these proceedings had been a white youth, Guillaume Ruffin, who had been found living with the Native Americans. Ruffin had been a member of Captain Jean Ribaut's garrison of Charlesfort, built in 1562. Rather than accompany the rest of the garrison in a desperate attempt to return to France in a rude, homemade boat, he had decided to remain with the local Native Americans and had married a native girl. He had been discovered by a Spanish party and taken as a prisoner to St. Augustine. There, he had agreed to guide Menéndez de Avilés back to Charlesfort.

RETURN TO SANTA ELENA

On August 20, 1566, Menéndez de Avilés came again to Santa Elena, staying for ten days. Besides an inspection of the fort and the area, and talks with Native American caciques, he ordered Captain Juan Pardo, along with 150 men, to march inland to establish Spanish posts at intervals. After Captain Pardo had departed, Menéndez de Avilés sent a messenger after him with a new directive "to discover and conquer the interior country from there [Santa Elena] to Mexico." Captain Pardo never reached the Gulf of Mexico, not

to mention Mexico, which was farther away than most geographers of that day realized. He did penetrate into northern Georgia on the first, and also on a second, expedition, "in the direction of Zacatecas and the mines of San Martín"—rich mines of silver, according to Native American accounts.

Although occasional French ships and small parties of Frenchmen were still encountered, the main French menace had been removed by Menéndez de Avilés soon after his first arrival in Florida in September 1565. By way of an inland march, he surprised the French garrison at Fort Caroline, near present-day Jacksonville, whose strength had been weakened by Captain Jean Ribaut's departure to the south, as well as several hundred Frenchmen onboard several ships. Menéndez de Avilés captured Fort Caroline and had all the men killed, sparing only women and children. He then sailed in pursuit of Ribaut and the French, finding them shipwrecked to the south of St. Augustine, at Matanzas. Suffering from hunger and thirst, the French surrendered, only to be massacred by the Spaniards. Menéndez de Avilés wrote to Spain's King Philip II:

> *And of a thousand French, with an armada of twelve sail who had landed when I reached these provinces, only two vessels have escaped, and those very miserable ones with some forty or fifty persons in them.*

MENÉNDEZ DE AVILÉS RETURNS TO SPAIN

Pedro Menéndez de Avilés was again at Fort San Felipe and Santa Elena on May 18, 1567. Along with thirty-eight men, he boarded a twenty-two-ton ship bound for Spain. The vessel reached the Azores Islands on June 15, and three days later it arrived at the port of Vivero, in Spain. For the next five years, Menéndez de Avilés remained in Spain.

On July 23, 1572, Menéndez de Avilés returned to America, landing at Santa Elena. He found the garrison in good shape, but relations with the neighboring Native Americans had deteriorated to a virtual state of war. Menéndez de Avilés wrote, regretfully, that "the Indians, as a rule, are better friends of the French, who leave them to lie in freedom, than to my people and the monks, who restrict their way of living; and the French can accomplish more in one day than I in a year."

From Santa Elena, Menéndez de Avilés led an expedition to the Chesapeake area to avenge the murder of several Jesuit priests and Spaniards. He failed to capture the ringleader of the local Native Americans, who had been educated in Spain, but eight natives were hanged in retaliation.

Menéndez de Avilés returned to Spain in 1572. When he left, there were at Santa Elena about twenty farmers and their families besides the soldiers of the garrison. The farmers raised crops of corn, pumpkins, peas and wheat. Pigs were also present, as well as cows, horses, sheep and goats. Present-day "marsh tackies" are said to be descendants of those Spanish horses. The farmers and their families were disappointed. They had been told that the land at Santa Elena was "as good as the plain of Carmona" in Spain. They had also been promised twelve farm animals, but had not always received them.

On his return to Spain, King Philip II entrusted him with an expedition against rebellious subjects in Flanders. Menéndez de Avilés died during the preparation. Shortly before his death, on September 8, 1574, he wrote:

> *I do not doubt that the affair of Flanders will be settled this winter. And with that, I shall be free to go at once to Florida, not to leave it for the rest of my life; for that is the sum of my longings and happiness. May our Lord permit it, if possible, and if he sees fit.*

The original outer coffin in which Pedro Menéndez de Avilés was buried in his birthplace, Avilés, Spain, is today kept in a small chapel of the nation's oldest mission, the Mission of Nombre de Dios, at St. Augustine. On his last voyage, the *adelantado* sailed for Spain on May 18, 1567, not from St. Augustine, but from San Felipe, at Santa Elena. Gonzalo Solís de Merás, in his *Memorial to Pedro Menéndez de Avilés*, wrote that Menéndez

> *would have liked well to tarry there a month, to confirm the friendship with these caciques and Indians; but the supplies he was leaving in the forts were very few and the rations the soldiers ate were very short; it was 10 months since he had written to his Majesty that he would soon be in Spain.*

The *Dictionary of American Biography* summed up his life in these words:

> *Menendez was a man of honor and of strong religious feeling, an expert seaman and a bold and resourceful leader. His early dealings with the Indians, before he not unnaturally lost patience, are a refreshing contrast to the conduct of many early explorers. Like most adventurers in colonization, he underestimated the difficulties; his plans were too large for his resources; he scattered his forces too widely, perhaps because of the scanty food supply. Nevertheless he did succeed in establishing Spanish power in Florida. He will be chiefly remembered, however as the author of the slaughters of Matanzas; these can be explained but never excused.*

FRENCH EXPLORATIONS

Most historical accounts deal with Charlesfort, the French fortification on Parris Island constructed in 1562 as an isolated attempt at settlement. According to these stories, the French, led by Jean Ribaut, sought to establish a base for future Huguenot settlement. Ribaut returned to France, we are told, planning to come back to the New World within a few months with more men and supplies. His return was delayed by war with England and internal strife in France. The garrison of Charlesfort, discouraged by his prolonged absence, built a boat and sailed for home. They reached France after a long and adventurous voyage—some had died on the way, and Guillaume Ruffin had elected to stay in the New World, or New France, as they called it.

Here, most accounts stop, diverting to the story of the French Fort Caroline, near present-day Jacksonville, Florida, and the death of Jean Ribaut and his men at the hands of the Spaniards under Menéndez at Matanzas, "the field of blood." Little-known contemporary documents, however, indicate a continued interest on the part of the French to maintain their foothold in the area they named Port Royal. At the same time, there is a strong conflicting interest by the Spanish to eradicate any signs of French occupancy and to prevent, by all means at their disposal, a resurgence of French influence at Port Royal.

Spain's King Philip II (of the Spanish Armada) placed great importance on a Spanish settlement north of Mexico and Cuba, in the same area coveted by the French. This is evident in a communication by Francisco de Ledesma, "dated in Vallodolid on the twenty-ninth of December of Fifteen hundred fifty seven. The princess, by command of his Majesty, Her Highness in his name" and reading:

> *The King—Know ye, our officials of New Spain who reside in the City of Mexico, that We are sending orders to Don Luis de Velasco, our viceroy of that country, that he is to provide for making a settlement on the point*

of Santa Elena, which is in Florida…to bring peace and to bring to the knowledge of our holy Catholic faith the natives of that country.

(All of the area from Florida to North Carolina was then called Florida, "the land of Flowers," by the Spanish.)

Two years later, on March 30, 1559, Velasco wrote to Luna:

Besides what is contained in our foregoing provisions by another cedula of ours dated at Vallodolid on the same day month and year of the aforesaid, we have charged and ordered you to give orders that the Province of La Florida and the Punta de Santa Elena shall be settled and that a strong settlement shall be made at the Punta de Santa Elena so that from it the attempt shall be made by preaching and kind treatment to bring the people of that land those provinces to the knowledge of our Holy Catholic Faith.

At this point, credit should be given to Mrs. Ruby C. Danner. All of the documents quoted in this article were collected by Mr. and Mrs. Howard F. Danner and may be found in a scholarly paper that was read to the Beaufort County Historical Society in 1942. Both of the Danners received a decoration by the Spanish government some years ago for their pioneering work.

At the same time that Philip of Spain was issuing his commands to settle Santa Elena, the French were showing an interest in this region. Their purpose was less to convert the Native Americans than to establish a strong point from which to raid the treasure fleets of Spain on their way home. In a letter from Velasco to Luna, dated August 20, 1560, we read:

The French come quite near to Santa Elena nearly every year to buy from the Indians gold, pearls, marten skins and other things…There are suspicions and some indications that the French who have settled at Los Bacalloas, which is not very far from the Punta de Santa Elena, are trying to come and take the part or parts which may be there and settle them so as to impede the passage of the Bahama channel. They will be sure to do this early if they find a port.—For the purpose of finding out whether there is a port at Santa Elena, or within a hundred leagues of coast from thereon, we have decided to send Pedro Menendez de Aviles.

The Bahama channel mentioned above refers to the fact that, in order to take advantage of prevailing winds, Spanish ships bound for Spain had

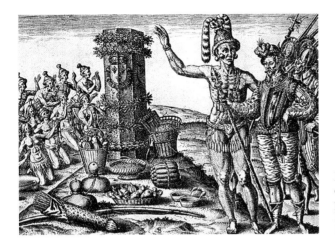

Representation of the monument placed by Jean Ribaut claiming Port Royal for France.

to follow the eastern coast of Florida to the coast of present-day Georgia, almost to the Carolinas, before turning eastward into the Atlantic Ocean.

Jean Ribaut's stories of Charlesfort and Fort Caroline are well enough known not to need elaboration. The French abandoned Charlesfort and the Spanish captured Fort Caroline, killing or taking prisoners all of the French then in Florida—at least the greater portion of them. The Spaniards continued to keep a wary eye on subsequent French activities in the Port Royal area.

Pedro Menéndez Marqués, a relative and successor of the former Menéndez de Avilés, wrote to the king from Santa Elena (Parris Island) on October 21, 1577:

> *And in the month of December last past, there appeared off that same fort* [St. Augustine] *a French galleon, and as the wind was contrary, she remained at anchor four days outside the bar, without being able to enter; then there came a gust of wind which sent her away from there and she came to this harbor of Santa Elena, where God was pleased that on crossing the bar, she should be wrecked.*
>
> *All the men escaped with their arms and munitions, and they came to land at this fort, which was burned and ruined, where they found your Majesty's artillery that was here, and threw it into the sea. When they first arrived, the Indians, thinking they were Spaniards, made very pitiless war upon them, in such wise that there were deaths on the one side and the other; but as soon as they understood that they were strangers, Frenchmen, and friends of theirs, they took them in and showed them much friendliness, and so they remain among them.*

Menéndez Marqués was undecided whether to go against the French or to remain at St. Augustine, having "no more than one hundred and thirty nine men, soldiers and laborers." Since his king had expressly commanded the strengthening of Santa Elena, he had lumber—cedar—cut, and loaded the posts onto the ships. After storms and assorted misadventures, he sailed with ninety-three soldiers for Santa Elena. A fort was constructed with the precut cedar posts. Menéndez Marqués then wrote in the same report quoted above:

> *I hold it as my opinion that, with the aid of the French, they* [the Indians] *will not fail to come here or to St. Augustine, to see if they can get in, although we are so much on the lookout that we shall not give them that opportunity. There is only one thing about it: if the Frenchmen have powder, they can do us much harm, and we shall even be in danger; but if they had none, I fear them not, even though they are many, for their vessel was large, whereof I found the poop here; according to its dimensions, she was a ship of five hundred toneles, and I even suspect that she was English, and not French.*
>
> *And I know likewise that she was ship they called* El Principe, *which fled from the armada at the Cape of Tiguron, for after she fled she came to Matacas, a harbor twenty leagues from Havana, where she took on meat and wood, which was given her there by Aloso Xuarez de Toledo: and she took on water and those who were on board the vessel said that she brought one hundred and eighty men.*

In the closing days of the year, Menéndez Marqués sent Captain Vicente Gonzales in a small boat to Santa Elena to scout the area. From the shore, Native Americans and an accompanying white man insulted the Spanish captain, "telling him that the Spaniards were worth nothing, and were hens, and that they [the Native Americans] had with them many friends, who would aid them." Considering his forces too weak to seek out the enemy, Menéndez Marqués felt impelled to bide his time. A dispatch boat from New Spain, carrying letters, was captured by a French corsair. Pedro Menéndez Marqués felt constrained to repeat what had been in the lost letters. In a letter to the king, dated June 15, 1578, he wrote:

> *When I heard in Santa Elena that the Frenchmen were alive among the Indians, and I knew likewise by some arquebus shots which I heard one night, I came to this fort* [so that] *they should not attack it while I was repairing the other; and here I found that all was well, and the Indians of this province were peaceful.*

The local Native Americans had been urged by others to attack the Spanish fort, aided by the French. They refused and informed Menéndez Marqués about this. Pedro Menéndez Marqués continued:

And I went to Santa Helena, and on the way I spoke with an Indian who is my friend. He told me that there are few more than one hundred Frenchmen, that they are divided among the caciques, that the principal cacique has forty of them, and they tell and advise the Indians not to trust us; that they will help them, and die among them. I sent to tell those same Frenchmen that they should escape, that I would send to get them, but they answer that they do not want to, because the Indians would hang them at once.

This has troubled me, owing to the evil seed they will sow among those Indians; for as to the rest, they will grow weary of going among the savages, and will come in search of me; and even the very Indians will not trust them and will kill them. I should much like to break the spirit of those Indians.

A ship appeared, presumably French and hostile. Later, two vessels came in sight of St. Augustine. Menéndez wrote:

I know that their whole object was to get those people from Santa Helena. I earnestly wish that I had men to prevent it, for there are people among them who have much knowledge of these provinces, and if they should leave the country alive, some trouble might result in the future; but may it please God that they do not escape.

On October 9, 1578, Diego de la Rivera wrote to the king from Havana, Cuba, that a ship had come from Florida with news that Pedro Menéndez Marqués had made friends with Native American chiefs, one of whom

brought to him a Frenchman, one of the Frenchmen who were there, among whom is one called Felix, one of those who were captured in the time of Jean Ribaut, a very good pilot who had escaped, he and others, with a boat in the year sixty-nine.

By August 26, 1579, Menéndez Marqués felt he had enough men to make a sortie against the Native Americans. Antonio Martínez Carvajal wrote an account to Philip II, from Havana, on November 3, 1579:

Pedro Menendez went forth from the said fort of Santa Elena against a village of Indians about 20 leagues from the said fort, the cacique of

which is called Cocapoy, who never had had peaceful or friendly relations with the Spaniards. The said general received tidings from him that he had, in the said village, 40 Frenchmen as a protection, and as friends. That village had about 400 Indians. The said Pedro Menendez, on seeing that this cacique never had a desire to be obedient, nor to give up the said Frenchmen, attacked the said village on the 29th of the said month, at daybreak with 200 men he had, who were arquebusiers; and he burned the village, and slew some of the Indians who defended it, and a number of the French, who let themselves be burned, sooner than surrender. He captured and holds prisoner the said cacique, his mother, and other Indian women, likewise 17 Frenchmen who he holds in custody in the said forts.

Returning to St. Augustine, Native Americans in Guale (Georgia) turned over to Menéndez Marqués "a Frenchman from the ship called *El Principe* which was wrecked at the bar of Santa Elena in the year '75. The said Frenchman came from it and this French captain is called Nicolas Astropo." Menéndez Marqués felt a glow of satisfaction. On April 2, 1579, he had written to the *audiencia* of Santo Domingo:

I finally learned the secret of the Frenchmen who were among them in the land. I find that there are twenty-four, not more, whom I desire extremely to get into my power, so that they shall not sow their evil teaching among these people; and for this I have need of the horses for which I am asking, because to think of overtaking these Indians on foot is impossible; and if I have horses they can be caught, and the French can be had.

In his own report on the Cocapoy action, Menéndez Marqués mentioned that "more than forty Indians were burned to death, and I seized two Frenchmen." He got hold of the other twelve Frenchmen by exchanging them for the Native American women he had seized. In his letter also occurs the ominous phrase "then justice was worked." He wrote:

I did not at once work justice upon the Frenchmen; not until now. I sent a boat to Santa Helena for some of them, and then justice was worked upon the rest there. I added those brought to those who were here, so that those on whom I worked justice, here and at Santa Helena, numbered twenty-three altogether. There remain three boys, one barber and one gunner, who are needed in those provinces as interpreters.

In Florida I hold ten Frenchmen: one is a surgeon, of whom there was much need; another is a German gunner, and the others are boys and interpreters. As I had ascertained that they had brought the German by force and had taken him from a ship, I had him placed in your Majesty's royal books, so that he should draw a ration and a salary. I condemned the others to be your Majesty's slaves, who should be employed in your Majesty's service in those provinces, and [arranged] *that they should be fed from the war stores. I entreat your Majesty to be pleased to do me the favor to command that your royal cedula be sent me, so that these rations may be approved, or let your Majesty's order what must be done with these people.*

From what has been heard only two men and one boy are now left among the Indians. They have agreed to surrender them. According to their confession, they well deserve death, for they have admitted having sacked and burned Margarita Island, Cumana, Guadinilla and other villages, and captured many ships. The captain was rich, because he offered me three thousand ducats as ransom, if I would grant him his life. It did not appear to me expedient for your Majesty's service that a man like him should get back to France. He was of the Florentine nation, and of a good lineage.

In March 1580, Pedro Menéndez Marqués reported to the king that Native Americans had delivered to him another French captain, named Roque, a native

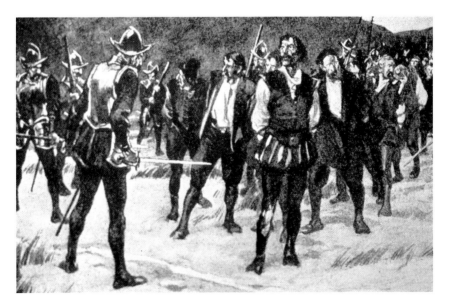

The Spanish under both Pedro Menéndez de Avilés and his successor Pedro Menéndez Marqués showed little mercy to any Frenchmen found in their territory.

of Rouen, twenty-three years of age, and three young boys. "I worked justice upon him, and the three I left for the last," he wrote. "I have news that there remain three others, whom the Indians say they will deliver to me within a very brief space. I suspect that there must be more. I shall do my utmost so that none shall remain."

Menéndez Marqués finally located the French fort, built by the survivors of *El Principe* and located somewhere near St. Helena Sound:

> *The last time I went to Santa Elena, I did my utmost to learn where the French had fortified themselves after they were shipwrecked, and at last found it in a wood near a river. According to the plan thereof there were more people than I had thought, because it was shaped in a triangle, with three cavaliers, all made of sod and faggots, with its curtains largely of wood; and it had from cavalier to cavalier sixty-three paces. I found five houses within, one piece of artillery of about twelve quitals, one man who was hanged and many bones of dead people. I burned and destroyed the whole fort, then I came to this fort. I heard afterward that the man hanged was a Spaniard.*

Having disposed of the French threat, Menéndez Marqués wrote, without knowing and almost prophetically, the following:

> *Here in this town I hear that five English vessels had entered the South Sea* [Pacific Ocean] *by the Strait of Magellan. Many years ago, the adelantado Pedro Menendez and I suspected this, and I even understand that he discussed it with your Majesty, in the Royal Council of the Indies. I hold it as my opinion that they aimed at a mark in that direction, and are about to hit another, which is at the back of Florida; although their having run along the whole coast, from the Strait of Magellan as far as New Spain, is an indication that they wish to have a thorough knowledge of it in order to enter that way.*
>
> *But I hold it for certain that the way out will be in this direction, for the cold regions are equal in altitude; and so I believe that they will come out there, owing to the voyage being much shorter; for the English have been trying for a long while to enter that way, and if this is not remedied in time by cutting them off from the passages, it will be a difficult thing to do it later on.*

To dispose of the English would prove to be more than difficult. The English would dispose of the Spanish after a long and hard struggle, which included the battle of Bloody Marsh on Saint Simons Island, Georgia, in 1743, and eventually ended with the Spanish cessation of Florida to the British in 1763.

BLACK COWBOYS

The American cowboy may well have had his origin not on the plains of Texas, but in the cowpens of the South Carolina Lowcountry. Settlers started raising cattle in the area soon after the coming of the English in 1670. They followed the Spanish, who had begun raising cattle in Florida a century earlier. The city of Cowpens, South Carolina, traces its origin to fenced-in enclosures called by that name, and according to one scholar, the word "buckaroo" may have its derivation from the Gullah word "buckra," a disparaging term for a white person.

Raising cattle was not what the founding Lords Proprietors had in mind. In 1674 the statement was made that it was their "design to have planters there and not grazers." However, settlers soon discovered that it was easier to trade with Native Americans for pelts and deerskins, and to raise cattle and hogs whose meat, packed in barrels, could be sold profitably in England, the West Indies and New England.

Despite initial beliefs that the prevailing weather was mild enough so that cattle could roam free and even survive winter seasons, settlers soon grew to depend on the use of cowpens, "in which cattle were kept and fed, especially during the cold seasons.

THE WORD "COWPENS"

Johnson, in his book *Traditions of the American Revolution*, wrote that "large flocks of cattle were kept at the time all over South Carolina, in settlements called cow pens; very much as still practiced by the Spaniards south of us." While the Spanish settlers of Santa Elena, on present-day Parris Island, had

cattle, their testimony showed that it was unlikely that they had much luck in raising livestock, considering their unsettled circumstances.

Thomas Christie, in a letter from Savannah, Georgia, dated December 14, 1734, wrote, "We have now completed a very large cow pen containing near 45 acres about a mile from the town on a pine barren, but little or no cattle to put in it."

An odd wording occurred in the will of Joseph Blake, of Berkeley County, dated December 18, 1750:

> *And fifteen hundred acres to be taken out of my lands on Cumbee* [Combahee] *River between Mrs. Hudson's land and the land I bought of Colonel William Bull, the land to run towards Calf Pen Savannah as far back as will take in the quantity of fifteen hundred acres.*

The word "Savannah" was used as meaning flatland, or meadows.

In 1893, Turner, in his book *Significance of the Frontier in American History*, wrote that "travelers of the eighteenth century found the 'cowpens' among the canebrakes and peavine pastures of the South and 'cow drivers' took their droves to Charleston, Philadelphia, and New York."

An article in an 1884 issue of the *Century Magazine* stated that "the ranch system had its beginning in Virginia and the Carolinas and the Spaniards in Florida, 'Cowpens', as they were then called, were established on lands not yet settled, and cattle were herded in droves of hundreds or thousands."

THE FIRST COWBOYS

In 1741, the estate of Robert Beath, of Ponpon, Colleton County, included cattle "said to be from five hundred to one thousand Head…Also a man used to a Cow Pen and of Good Character." That man was undoubtedly black, and that may have been the earliest mention of the American cowboy, even if not called by that name.

Open grazing, and even the use of large cowpens, was familiar to many Carolina blacks, especially those who had come from the Gambia region of the eastern coast of Africa. There, cattle herds grazed in open meadows, or savannahs, near the river. At night, the cattle were driven within a cattle fold ("cowpen") and guarded by a few herders.

According to Verner W. Crane in *The Southern Frontier 1670–1732*, cattle grazing in the Port Royal area was one of the causes leading to the outbreak,

in 1715, of the Yemassee Indian War, which nearly ended the fledgling Carolina settlement. Crane stated:

> *The intrusion of the cattle-raisers which reached its peak in 1707, led that year to the passage of an important act "to Limit the Bounds of the Yamassee Settlement, to prevent Persons from Disturbing them with their Stocks, and to Remove such as are settled" within the bounds described.*

In the war that followed, Schenkingh's Cowpen, on the Santee River, was the settlers' northernmost garrison outpost. Armed men remained in that area, at the cowpen of Mr. Benjamin Schenkingh, consisting of seventy white men and forty black men. In the Yemassee War, blacks and whites fought together against a common Native American enemy. The settlers had erected rude breastworks for protection, but when confronted by a large force of hostile Native Americans, their leader was persuaded to treat them and "suffered the Indians to come amongst them, who taking the opportunity drew out their knives and Tomahawks from under their Cloaths and knocked 22 of our men on the head, burnt and plundered the Garrison."

An earlier Schenkingh, Bernard, a settler who came from Barbados, had died in Carolina in 1682, leaving four plantations. About one of them, on James Island, appraisers of the estate said that "in sight and by account appeared 134 head of Cattle, one negro man."

Peter H. Wood, who spoke at a meeting of the Beaufort County Historical Society on May 10, 1978, was among the first modern scholars to connect the origin of the American cowboy with the early cattle industry of the Carolina Lowcounty and point to the likelihood that the first American cowboys were black.

In his 1974 book, *Black Majority—Negroes in Colonial South Carolina from 1670 Through the Stono Rebellion*, Wood wrote that early settlers soon changed from accepted European habits of animal husbandry:

> *A far different pattern actually emerged. The settlement was so sparse and the land so abundant that animals could be allowed to graze freely, requiring almost no time from the limited labor force. Furthermore, the climate proved mild enough and the forage plentiful enough so that there was no necessity for annual butchering…this situation was so unfamiliar for Englishmen that it aroused concern among the Proprietors. It has been "our designe," they stated indignantly, "to have Planters there and not Graziers."*

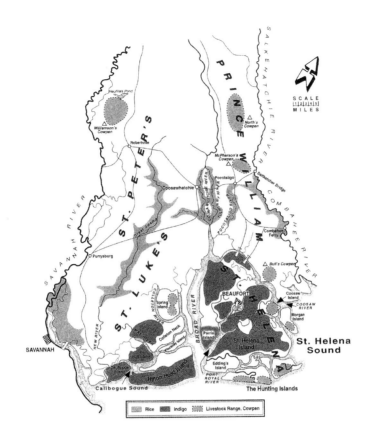

Colonial crop distribution, 1760s

A map showing the location of cowpens and the distribution of rice and indigo crops in 1760.

Peter H. Wood concluded by stating that:

> *It is even possible that the very word "cowboy" originated through this set of circumstances....Might not the continued predominance of "cowboy" over alternative terms such as "cattlemen" represent a strange holdover reflective of early and persistent black involvement in the American cattle trade? This most American of words was already applied during the colonial period to men stationed at cowpens with herding responsibilities.*
>
> *As late as 1865, young Negroes with livestock responsibilities were still being designated as "cow boys" (two words) in the plantation records of the Southeast.*

Government entered the regulatory field as early as 1681, when a law was passed in Charles Towne stating in part that "beef and pork are two of the principal commodities" of the province. Barrels containing meat were to be marked as to content; the mixing of beef or pork with "bulls' flesh, boare's flesh, or any other unmerchantable or corrupt meat" was forbidden. Exports from Charles Town from June 1712 to June 1713 included 1,963 barrels of beef and 1,241 barrels of pork.

With the proliferation of cattle, owners branded their animals and registered their brands in Charles Town, as required by law. Unbranded cattle were not to be slaughtered, but probably were killed occasionally. So, it may be said that cattle rustling also had its start in the Carolina Lowcountry.

Among the record of stock marks in South Carolina, 1695–1721, two may be of local interest since they involve members of families well known in the Lowcountry.

> *May 12* [1698] *This Day Came John Ffripp & Recorded his Marke for Cattle & Hoggs wch. Is a Cropp & a Hole in ye right Ear and a Cropp and a Slitt in ye Left, being formerly ye Marke of William Macfashion upon Edistoe-Island, & by him Assign'd to ye sd. Ffripp for all Cattle Hoggs on ye sd. Island of that Marke.*

Another entry dated March 8, 1694–95, reads:

> *This day Came Mr. John Hamilton of Edisto Island in Colleton County, and recorded his Sonn Paul Hamilton his Marke of Cattle & Hoggs & ct (as followeth) In Each Ears a Swallow Taill cutt out in Each Eare; his brand marke as…marked on the Left Buttock.*

A CHANGING ECONOMY

Wandering cattle were especially subject to being killed by Native Americans. The Native Americans complained, justifiably at times, that cattle grazing at will damaged or destroyed their unfenced farm plots. Such grievances contributed to the Yemassee War of 1715.

The Yemassee War proved a major setback to cattle raising in the Lowcountry. Among four hundred or more settlers killed in the uprising were cattle raisers. Many of the cattle were slaughtered or died. Much of the grazing land remained untended for years before settlers felt sufficiently safe in returning.

By the 1730s, cattle raising had regained its importance, but no longer was it connected with Lowcountry parishes. Cattle herds were now to be found in the backcountry, such as near the location of the previously mentioned town of Cowpens.

Rice, indigo and cotton took the place of cattle raising in the Sea Islands and the adjacent mainland, but they also disappeared in turn. Lately, however, on the plantations of the Lowcountry, large herds of cattle of good stock may again be seen grazing in fenced fields, but these fields are no longer called cowpens.

Onetime county agent Jack Queener stated that on January 1, 1976, there were 7,300 cattle and calves in Beaufort County, of which 7,000 were beef cattle and 300 dairy. Breeds included some 2,500 Angus, 2,500 Hereford and perhaps 1,000 Santa Gertrudas.

The income to Beaufort County "ranchers" from beef cattle and calves in 1975 totaled $365,000; from dairy cattle and products, $226,000. The whole area staking claim to the beginnings of the cattle industry and the American cowboy in the Carolina Lowcountry warrants a great deal more study than scholars and historians have devoted to it in the past.

RICE AND INDIGO

History abounds in ironic contradictions, and the history of the Carolina Lowcountry is no exception. Several years ago, a German chemical firm, Badische Anilin und Soda Fabrik (BASF), sought to build a factory at Victoria Bluff, not too far from Beaufort and very near to Hilton Head Island. The attempt was not successful. BASF achieved its international reputation with the manufacture of dyes, the most important of which was indigo. Colonial South Carolina's wealth and resulting achievements were also due, in part, to the cultivation and export of indigo. It was the same dye, even if one was produced naturally in fields and the other was the result of experiments in chemical laboratories.

Colonial South Carolina derived most of its wealth from a relatively small strip of land running parallel to its seashore and extending about twenty miles inland. From this coastal belt came most of its riches during the first two hundred years of its existence. This wealth made it one of the most prosperous and culturally advanced of all his British majesty's American colonies.

During this period, three commodities furnished the bulk of Carolina's exports: rice, indigo and cotton. Rice and indigo culture flourished especially during the colonial era. Cotton cultivation achieved prominence only after Eli Whitney invented the cotton gin on a plantation just outside of Savannah shortly after the American War for Independence.

These three crops laid the foundations of the wealth of prominent historical families of the Lowcountry: families bearing the names of Heyward, Bull, Coffin, Fripp, Chaplin and Barnwell. There were others, but the wealth and resulting opulence was confined to a relatively small proportion of the population. This small proportion again rested on a broad foundation of black slave labor. Only slave labor could furnish the large numbers of workers needed for clearing the swamps and tending the

fields in the hot, humid summers of Carolina. For better (and for worse) these basic facts would affect the lives of the people and the history and economic development of the state for generations down to the present day.

Rice was the first of the two crops to flourish in South Carolina. The first settlers had brought young plants with them from Barbados in the West Indies. It was planted experimentally, along with indigo and other plants, as early as 1670. Some authorities credit Henry Woodward with obtaining a bag of seed rice from the captain of a ship coming from Madagascar in 1685. Others state that Landgrave Smith obtained the first rice.

Be the truth what it may, from 1720 to 1729, South Carolina's planters exported 264,755 barrels of rice. From 1730 to 1739, exports rose to 499,525 barrels. This rice was exported in the holds of ships sailing from the three ports of the state: Charles Town, Georgetown and Beaufort. Beaufort was a bustling seaport during much of the colonial period. From March 1764 to March 1765, 360 vessels cleared the port of Charles Town, 24 cleared from Georgetown and 40 from Beaufort. These ships were laden with 111,310 barrels of rice and 545,620 pounds of indigo.

The British government encouraged the cultivation and export of rice. It found a ready sale not only in the British Isles, but also in European countries, especially Holland, Germany and the Austrian Empire, where grain foods were scarce during the winter months. Hot rice dishes, with butter added and sweetened with sugar and cinnamon, were highly desired luxuries during the cold weather season.

The early settlers first attempted to grow rice on high, dry ground, but they soon found the marshy areas of the Lowcountry to be better suited. A Hessian officer during the Revolution, Captain Johann Hinrichs, wrote in his diary:

> As is well known, the entire coast from Cape Hatteras southward is flat, marshy land, for the greater part still uncultivated and suited for the growing of rice only; a habitat of snakes and crocodiles…rice demands a soil which is under water nine months out of every year.

Initially, only inland, freshwater swamps were used. Since these depended on rain for moisture, the water supply was unreliable. In the 1750s, planters began to transfer operations to the swamplands of the tidal rivers—locally, the Edisto and the Combahee. These rivers provided a regular and constant supply of fresh water, which could be regulated by the rise and fall of the ocean tides. Fields could be flooded and drained as

desired by the use of sluice gates and canals, copied from methods used in the marshes of England and reclaimed sea areas of the Netherlands.

At Old House, the birthplace of Thomas Heyward Jr., signer of the Declaration of Independence and brother of Daniel Heyward, the richest planter-to-be of the Lowcountry, the old tidal pool adjoining Hazzard's Creek may still be seen. Still present are the two sandstones with diagonal grooves that once held the floodgate for the tide-powered mill, and also the piece of an old mill wheel brought over from Scotland long ago.

Timothy Ford, who came to Beaufort district shortly after the American Revolution, noted in his journal:

> *The first peculiarity that strikes a northern person is the lands being tilled by the dint of manual labour without the assistance of machines—'til neither plowed nor harrowed, but hoed; the hoe being the only instrument used not only in rice, but indigo, corn &c.—.*

Rice was ordinarily planted in April while the soil was still wet. Trenches were dug, eight to twelve inches apart. One bushel of rice seeds sufficed to plant one acre of land. Within a week, the seeds sprout and grow, accompanied by weeds, necessitating extensive hoeing. "This is the critical time," wrote Timothy Ford, "& requires the vigilance & judgment of the planter, for heavy rains or severe droughts prove equally fatal & put him to the necessity of replanting." During this period, water is brought onto the field, care being taken that it does not remain longer than necessary, usually from six to eighteen hours.

> *Shortly after this, the stalk forms a joint like oats at about 4 inches from the ground and once this is fairly formed & the stalk is proceeding to it second joint the planter thinks himself pretty safe & the crop mostly out of danger.*

Following another period of hoeing and inundation, the rice grows, in appearance very much like oats, yellowing as it ripens.

> *In September about the middle the negroes enter the field each with a small sickle in his hand & cutting up the rice lay it upon the stubble where it remains for one day to dry & cure…it is then bound up in sheaves & put in small cocks, & then at leisure transported…& put up in large stacks ready for threshing.*

An interesting sidelight is that this was the best time for obtaining fine butter from cows, which were turned loose in rice fields to fatten and "give the richest milk in great plenty." It was accordingly called "rice-butter."

Hand threshing was eventually supplanted by the construction of pounding mills, also often operated by utilizing tidal power and/or the use of steam engines. The American Revolution, in ending English import duties on rice and ending limitations on exports to non-English markets, made the growing of rice extremely profitable for the Lowcountry planter.

The War Between the States brought an end to a seemingly inexhaustible, trained, docile labor supply. Free labor balked at the hardships of the rice fields. Then, too, recurring storms between 1893 and 1920 destroyed crops and irrigation systems. Aside from the calamities of Nature, growers of rice in Louisiana, Arkansas and Texas were producing it cheaper and more efficiently than could be done in the Lowcountry, due primarily to the fact that these fields were higher and had a firmer bottom. They could, therefore, be worked with machinery, whereas Carolina's rice fields were too boggy and soft for heavy equipment. Duncan C. Heyward, whose family had grown rice from the early days, was one of the last planters to abandon its growth.

An observant eye may still locate vestiges of old rice fields along U.S. 17 and the banks of the Combahee and Edisto Rivers. After

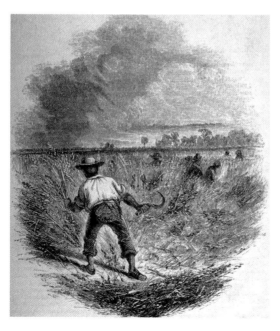

Slaves harvesting rice.

the decline of rice cultivation, no other use was ever found for these fields (aside from hunting waterfowl and bass fishing). It is difficult today to imagine that these abandoned, overgrown swamps were once prosperous, tilled fields, which supported the wealthiest and most highly cultured society in the country at that time.

The indigo plant, *Baptisia tinctoria*, grows wild in the Carolina Lowcountry. It produces a dye comparable in color quality to the cultivated plant, *Indigofera tinctoria*, but the latter is more productive. Indigo has been grown experimentally and successfully since the beginning years of the Charles Towne settlement. However, it remained for a young girl, Eliza Lucas, who was to become Mrs. Eliza Lucas Pinckney by marriage, to experiment successfully with its cultivation and the production of its dye.

Indigo dye was a highly sought after commodity in Europe, the society of which delighted in rich colors. In 1747, a committee of the English Parliament determined that the French West Indies supplied all of Europe with the dye. Britain alone purchased some 600,000 pounds of French indigo at a time when the two countries were engaged intermittently in a life and death struggle for supremacy in Europe and the New World.

In 1748, an act of Parliament allowed a sixpence bounty per pound on all indigo raised in the "British American plantations" and imported directly to Britain. Eventually, the bounty was lowered to fourpence.

Eliza Pinckney was the right person at the right place at the right time. Her father, Major George Lucas, a British officer, left his plantations

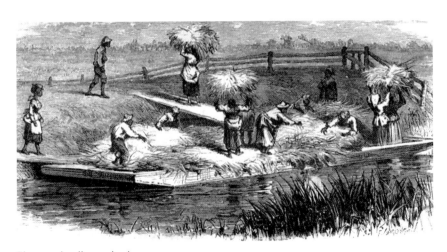

Slaves unloading a rice barge.

along the Wappoo, Waccamaw and Combahee Rivers to her care when the War of Jenkins' Ear called him to the Caribbean in 1739. Young Eliza was not content with merely operating the plantations. She experimented with seeds sent by her father from the West Indies. In the early summer of 1741, she wrote in her letter book:

> *I make no doubt indigo will prove a very valuable commodity in time if we could have the seed from the West Indies* [in] *time enough to plant the latter end of March, that the seed might be dry enough to gather before our frost. I am sorry we lost this season. We can do nothing towards it now but make the works ready for next year.*

Eliza Lucas persevered, even after her marriage on May 27, 1744, to Charles Pinckney, a forty-five-year-old widower. The 1744 indigo crop made seventeen pounds of indigo, of which six pounds were sent to England. A letter from London, dated December 3, 1744, and printed in the *South Carolina Gazette* stated:

> *I have shown your Indigo to one of our most noted brokers in that way, who tried it against some of the best French, and in his opinion it is as good…When you can in some measure supply the British demand, we are persuaded, that on proper application to Parliament, a duty will be laid on foreign growth, for I am informed that we pay for indigo to the French 200,000 pounds per annum.*

From a mere 5,000 pounds of indigo produced for export in 1746, the figure rose to 46,000 pounds in 1747, 135,000 pounds in 1748 and eventually to more than 1,000,000 pounds. The province of South Carolina, which had paid a bounty on production in initial years, soon repealed it. The treasury feared it would not have sufficient funds to pay the bounty.

Indigo raised around Beaufort for many years commanded top prices on the market and continued to be grown locally even after the Revolution, when most production had stopped. As late as 1828, William Elliott of Beaufort district sought to encourage the widespread cultivation of it. Of fifty-five plantations on Hilton Head Island at the outbreak of the American Revolution, most grew indigo as the main money crop. The export of indigo was aided by the arrival in Charles Town in 1756 of Moses Lindo from London. In the *South Carolina Gazette* of November 11, 1756, appeared the following:

Moses Lindo gives this public notice, that he is arrived from London, with an Intent to purchase Indigo of the growth and manufacture of this Province, and to remit the same to his constituents in London, classed, sorted and packed in a manner proper for the foreign market.

The liquid solution, containing indigotin, was next drained off. Oxidation of the indigotin solution was achieved by beating it with paddles, using manual labor, for fifteen to twenty minutes. Oxidation was complete when the solution acquired a bluish tinge. Limewater was slowly added, accompanied by continual stirring, until the mixture turned cloudy. The liquid was again beaten with paddles until the formation of granules. Precipitation of the indigo dye required from five to six hours, after which the bulk of the water was strained off. The remaining paste was gathered in bags, which were hung up to drain some more. The bags were then pressed and the paste was spread on boards, cut into two-inch squares and placed in a drying house. After being turned three or four times daily (it was also essential to keep flies from the drying indigo) the dry paste was packed in barrels for shipment to market.

An interesting sidelight on the production of indigo is a contemporary observation that the vapors arising from vats and drying sheds, incidental to the process of extracting dye, could be injurious to the health of the workers, especially affecting the fertility and childbearing capacities of female slaves.

The indigo plant.

In 1773, shortly before the War for Independence, South Carolina's exportation of indigo rose to 1,107,660 pounds. The conflict caused an end to the export trade with England and the corresponding loss of the English bounty. Rather than resume imports of indigo from an independent South Carolina, Great Britain encouraged the production of indigo in British India. This was followed by the production of indigo dye by an English chemist in his laboratory.

Indigo production for local consumption continued in some sections of South Carolina, notably around Beaufort and Orangeburg, until coal tar dye substitutes supplanted the natural product. Other factors added to the decline of indigo culture. There was the development of the cotton gin, which caused a boom in the production of Sea Island cotton and siphoned off the skilled labor indigo needed for its manufacture. Then, too, the ease of transporting cotton as opposed to indigo sounded the death knell of an industry, which, according to one historian, brought more benefit to South Carolina than the precious metal mines of Mexico brought to imperial Spain.

Major George Lucas, as governor of Antigua, sent Nicholas Cromwell from Montserrat to assist his daughter in the technical aspects of producing indigo dye. In her letter book, many years later, Eliza Lucas Pinckney wrote that "he made a great mystery of the process…and threw in so large a quantity of lime water as to spoil the colour."

Helping her to frustrate the sabotage attempts of Cromwell was a neighbor, Andrew Deveaux, who was also instrumental in perfecting the process of producing the dye. An ardent racer of horses and owner of a plantation in Saint Helena's Parish, it should be mentioned that he was also the father of one of Beaufort's Revolutionary War figures, Colonel Andrew Deveaux, a hero on the Tory and British side.

Indigo required a dry soil, as opposed to the wet soil required by rice, so the two crops complemented each other. About April 1, the soil was furrowed with a drill plow or hoe some two inches deep, and seed was sown thinly. One bushel usually sufficed for four acres. After ten to fifteen days, the plants would appear, and hoeing was essential to loosen the soil around the young sprouts. By late June, indigo plants were in full bloom and ready for cutting, since leaves were then thick and filled with juice. The plants were carefully cut and gathered together. They were then steeped in water and allowed to ferment for about twelve hours.

REVOLUTIONARY SOLDIERS

CONTINENTALS AND MILITIA IN SOUTH CAROLINA

Left mainly to her own resources, it was through the depths of wretchedness, that her sons were to bring her back to her place in the republic, after suffering more and achieving more than the men of any other State.

These words by George Bancroft, American historian, are a tribute to the citizen soldiers of South Carolina in the American Revolution. Edward McCrady, who wrote a comprehensive three-volume history of the Revolution in South Carolina, is equally insistent in his praise of the militia. In the concluding pages of his work, he wrote:

> *In other States the militia was occasionally engaged in operations with the Continental forces, and sometimes, though rarely alone, in enterprises against the enemy. The complete overthrow of all civil government in South Carolina, rendering the employment of militia on either side within her borders impracticable, in their place partisan bands were organized by the Whigs, upon the nucleus of the old militia organizations, and, practically self maintained for the last three years of the war, again and again upheld the struggle while there was not a Continental soldier in the State.*

There is another side to this story, and any discussion of the topic of the Continental soldier and the militia is one that still causes speakers and writers in the Lowcountry, and the rest of South Carolina as well, to be extremely careful in their choice of words. Many South Carolinians have not forgotten that their particular heroes of the American Revolution—Sumter, Marion, Pickens, Hayne and their followers—were not eligible for membership in the General Society of the Cincinnati. Membership was restricted to officers of the Continental army and their oldest male descendants.

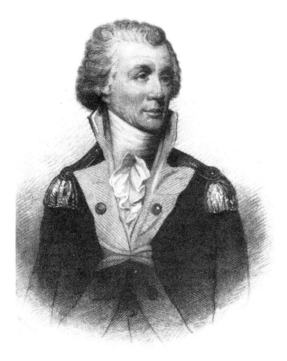

Thomas Sumter served as both a Continental officer and a leader of the state's militia.

"CONTINENTAL" AND "MILITIA"

The militia was the traditional armed force of the English colonies. Locally enlisted and trained, often led by officers elected by the men and serving only for short, limited periods of time, the war began with militia companies besieging the British troops in Boston in 1775. In the battle of Breed's Hill (Bunker Hill) on June 17, 1775, untrained militiamen dug themselves in on top of the hill, stood their ground as regular British troops advanced with fixed bayonets and repulsed them twice. A third British attack carried the hill and forced the Americans, who were nearly out of powder, to retreat. Approximately a thousand British casualties against four hundred American, and a successful withdrawal from an exposed position, encouraged popular belief in the colonies that militia were the equal of trained troops.

This belief was not fully shared by all, and in the fall of 1775, Congress charted the organization of the Continental army. It was to be composed of twenty-six infantry regiments, one regiment of riflemen and one of artillery, based on the British model. The troops, numbering on paper 20,372 men, were to be paid, supplied and administered by the Continental Congress.

Since the war was expected to be a short one, enlistment was only for one year. The Continental army was officially formed on January 1, 1776, with fewer than 10,000 men.

Each state was given a quota of regiments to raise. Thus, in early 1776, Congress authorized fourteen Continental battalions to be raised in the Southern states and detached Major General Charles Lee, one of Washington's generals, to advise the defense of Charles Town. Lee counseled the abandonment of fortifications on Sullivan's Island. South Carolina's Colonel William Moultrie, a Continental officer commanding both regulars and militia, declined to do so and decisively repulsed a British fleet carrying a British army on June 28, 1776. After the battle, General Lee praised the conduct of Colonel Moultrie and his men very highly. This American victory forced the British to return north, giving the Southern colonies almost three years' respite from the ravages of war. It also maintained the popular faith in the militia system.

There are numerous examples of the reliability of Continental and especially of militia troops in the Lowcountry. It may suffice to cite but one: the destruction of Fort Lyttelton, located in Beaufort's Spanish Point area. About twenty Continentals and a large contingent of militia garrisoned the fort. On February 1, 1779, a British warship approached the fort causing the militia to flee. With the majority of his troops gone, Fort Lyttelton's commander, Captain John la Boularderie de Treville, reluctantly spiked the guns and evacuated the fort. A court of inquiry held at Purrysburg, March 13, 1779, by order of Major General Lincoln and continued by different adjournments to the sixteenth ended with the following pronouncements:

> *Captain De Treville had the command of the fort, with about 20 Continentals, and a number of militia; when the enemy appeared, the militia all left him; he, therefore, spiked up the guns and blew up the fort… The Court of Inquiry, of which Major Huger is president, have reported that, on a thorough investigation of the matter laid before them, the court are of the opinion that Captain De Treville, in spiking up the guns, and evacuating the fort, at Port Royal Island, did no more than his duty, and rather deserves praise than censure for his conduct on this occasion.*

The small force of Continental officers and men then joined the troops under the command of General Moultrie that had just arrived from Charles Town to aid in repelling the British invasion. They participated effectively in the battle of Port Royal on February 2, 1779, and on this occasion an

anecdote relates that an American artillery piece was capably served by four officers: Captain de Treville commanding, Captain Mitchell aiming, Captain Dunham loading and Captain Moore firing.

"THE MILITIA RAN"

Continental officers usually had a low opinion of militia. In General Moultrie's *Memoirs*, relating to his campaigns in the Carolinas, are numerous quotations like the following:

> *The preceding letters show what a disagreeable, unpleasant and dangerous situation General Lincoln was in while at Purisburgh, with his army, being so near the enemy, whose force of veteran troops was superior to him; and his most composed of militia who were so discordant, that they disobeyed every order which was disagreeable to them; and left their posts and guards whenever they pleased, and that with impunity.*

General Moultrie ended his account of the American defeat at Camden, South Carolina, with the following graphic portrayal:

> *General Gates endeavored to rally some of the militia, to cover the retreat of the continentals, but in vain. The* [British] *cavalry pursued the fugitive militia, upwards of twenty-five miles, and made a dreadful slaughter among them; the road on which they fled, was strewn with arms, baggage, the sick, wounded and dead; the whole of the baggage which was ordered on the day before, fell into the enemy's hands, and eight field pieces.*

In spite of these adverse passages, General Moultrie realized the militia soldier was not to be altogether condemned or ignored. In discussing the Battle of King's Mountain in the northern part of the state, he wrote:

> *This battle, as well as many others under Generals Sumpter, Marion and others, proves that the militia are brave men, and will fight, if you let them come to action in their own way. There are very few instances when they have drawn up in line of battle that they could be brought to stand and reserve their fire until the enemy came near enough. The*

charge of the bayonet they never could stand, and it can never be expected that undisciplined troops could stand so formidable an attack.

The ordinary member of the militia, especially in the Carolina Lowcountry, was confronted with a number of problems his counterpart in other colonies did not face in so drastic a fashion. The Tory element was very strong hereabouts and ever ready to rise when the occasion warranted. He was a part-time soldier with little training or battle experience. He was usually called into service when the British or Tory enemy, or both, approached his home. Always in his mind were the problems of his family and his farm, both of which relied on his presence.

In the Carolina Lowcountry, between 1779 and the end of the war, the tide of the battle changed fast and furiously. Even as late as 1783, when the outcome of the Revolutionary War was no longer in doubt, Colonel Andrew Deveaux raided his former hometown Beaufort with a force of Tories and held the town until a neighbor and former acquaintance, General Barnwell, could assemble sufficient militia to drive the Tories out.

A QUESTION OF PAROLE

The British usually freed militia prisoners after capturing them, but their paroles often demanded that they not fight against the British in the future. When Colonel Harden, after the fall of Charles Town to the British, made a dashing raid into this area, he was sadly disappointed at the lack of response from former American soldiers and members of the old militia who had given their paroles to the English. In a letter to General Marion, Harden wrote:

> *You will receive a letter from Colonel Hayne with the commission. You will hear his reason for not accepting it. This gentleman has kept many from joining me, and is staying on too much formality...I find the leading men very backward, which keep many thus, so hope you will send me or some other officer some proclamation, or orders what is to be done. They all say they wait for your army to come their way, then they will all turn out.*

Colonel Isaac Hayne had good reason for being cautious. He had given his parole to the British, but violated it because he considered the British had

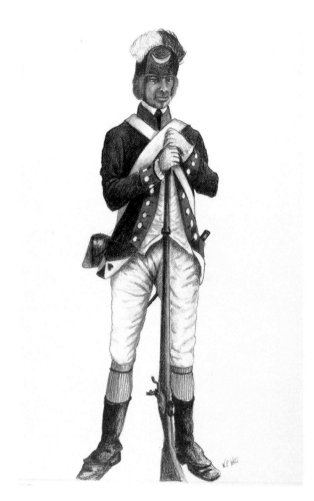

A member of the St. Helena Volunteer Company of Militia, which served in the South Carolina Lowcountry. During the latter portion of the Revolution, elements of the unit fought as partisans with Colonel William Harden.

broken their terms first. Finally, he did "turn out," only to be captured by the British. After several hearings, he was hanged in Charles Town for violation of his parole. This execution was an example that struck home to many other members of the militia who also had returned home after giving their paroles to the British, promising not to take up arms against the royal cause.

General Moultrie touches upon this aspect of the prospects the militia faced when he wrote in his *Memoirs*:

> *The defeat of Colonel Ferguson, and the retreat of Lord Cornwallis to Winnsborough, encouraged the American militia to collect and repair to the camps of their respective commanders; their turning out again obliged them to submit to strict discipline, and fight bravely: for, if they should*

be taken a second time, they were sure to be hanged: their only place of safety was with the army.

ORGANIZATION OF THE MILITIA

At the outbreak of the American Revolution, South Carolina, through its provincial congress, determined that little reliance could be placed in the old-style militia system. Encompassing, as it did, members of all political opinions, it could not be relied upon by either the Whig or the Tory side. The provincial congress determined to form three regiments, officered by "gentlemen," with soldiers to be enlisted by hiring. There was no difficulty in securing officers, but too often the rank and file consisted of men who had fallen afoul of the laws and had been given a choice by the courts of punishment or enlistment.

In addition to the three regiments, a militia was retained. Militia colonels, especially those in the Lowcountry, were urged to divide the companies of their regiment into three divisions, one of which would be ready at any time to march at twelve hours' notice but would be called upon only on special occasions.

In July 1779, the general assembly passed an act providing for the recruitment of regular regiments, which had been previously organized by means of higher bounties. The tour of duty was restricted to two months from the time of arrival at headquarters. At the end of that period the militia was to be relieved by another group. Under no circumstances were they to be kept on active duty longer than an additional ten days.

Regarding this act, General Sumter was to write:

> *With respect to drafting or engaging the militia to serve three or four months, notwithstanding the number required might be small, yet I doubt the measure would not take, as the law requires them to serve but two months, and short as the time is they seldom stay one half of the time. My brigade turned out tolerable well upon the late occasion, but discovering the indolence of their neighbours and that the people of the adjacent states made them complain of injustice in point of service, and there uneasy to go home—in which by one means or another they are all gratified.*

How gravely the efficiency of South Carolina militia was affected by such regulations is open to conjecture. If casualties are any indication, those of the battle of Savannah on October 9, 1779, may be of interest. The Continental troops of South Carolina, numbering 600 men, had 250 casualties. The

Charles Town militia, although by all reports also hotly engaged, had but one officer killed and six wounded.

On May 12, 1780, General Lincoln surrendered Charles Town to the British under Sir Henry Clinton. Some six thousand American soldiers were taken prisoner. Of these, about sixteen hundred were Continentals, the rest militia. With the surrender of these troops, all organized resistance in South Carolina ceased for the time being. The most destructive and hardest fighting was yet to come, and it was in connection with military activities to be that much of the dispute regarding militia and Continental soldiers arose.

For the entire period of the war, 137 battles and engagements have been listed by Edward McCrady as taking place on South Carolina's soil. In the first two years of the American Revolution, 1775 and 1776, nine battles took place. At the battle of Fort Moultrie, both North and South Carolinians took part. In the other eight, only South Carolinians fought on the American side.

During the years 1776 and 1778, there were no military clashes of note in South Carolina. In 1778, Continentals did take part in an expedition to Florida, which resulted in little more than American casualties. In 1779, there were nine engagements in the state, in which, on the American side, only South Carolina Continentals and militia took part.

In 1780, there occurred thirty-six engagements. In eight of these, Continental troops were engaged; in twenty-eight others, partisan groups (in the absence of a state government, there could be no talk of militia) composed of North and South Carolinians and Georgians took part. In twenty-two engagements, only South Carolina troops were involved.

In the last two years of active warfare, 1781 and 1782, eighty-three battles and engagements were fought. Continental troops from Southern states took part in nine of these; South Carolinians and Continental troops fought together in another ten. In sixty-four engagements, only South Carolina troops faced the British enemy.

Edward McCrady recapitulates as follows: of 137 engagements in South Carolina between British, Tories and Native Americans on one side, and Revolutionaries (American Whigs) on the other, 103 were fought by South Carolinians alone.

In twenty others, South Carolinians took part with troops from other States, making it all one hundred and twenty-three battles in which South Carolinians fought, within the borders of their State, for the liberties of America; leaving but fourteen in which troops from other States fought within the same without her assistance.

In addition to fighting within its borders, South Carolina troops participated in two battles of Savannah, and took part in the siege of Augusta, Georgia, in 1780, as well as 1781. They also took part in campaigns in the neighboring states of North Carolina and Georgia.

The soldier of the Continental line often had just as pressing problems as the soldier of the militia. Pay was often in arrears, and food and equipment were short in supply. The officers of the state regiments were usually natives of the state itself, but the men were enlisted wherever possible. Discharged British soldiers and deserters were taken on in such numbers that General Nathanael Greene remarked, "At the close of the war we fought the enemy with British soldiers; and they fought us with those of America."

In order to fill set quotas, courts often sentenced vagrants and offenders of the law to enlist in the Continental army in lieu of other punishment. The pay, although usually in the form of money in South Carolina, was sometimes in the form of black slaves, supplies and salt, all of which often first had to be captured from the British enemy or sequestered from suspected Tories of the countryside.

Discipline was maintained partly because of training and partly because the punishment meted out to Continentals for violations of military regulations was a great deal harsher than was the case with soldiers of the militia.

History seems to bear out the statement that no body of irregular troops, however brave and determined, is able to stand up to, much less defeat, a well-disciplined and armed body of regular troops unless there is a great disparity of numbers. In the Carolina Lowcountry, the population was divided strongly and evenly between adherents of the Continental Congress and those loyal to the English Crown. The presence of regular troops of either side often determined the balance of military power.

The daring and heroic exploits of Marion, Sumter, Harden, Pickens and other partisan leaders revived and maintained the spirits and morale of the supporters of American liberties. This was true even after the complete collapse of the state government and the abandonment of the state by organized regular American troops. The partisan soldiers, however, were not sufficiently strong to destroy the solid base established in coastal South Carolina by four thousand well-trained British troops and their Loyalist detachments and adherents.

General Washington stated, "I send you a General," when he dispatched General Nathanael Greene to the South. It was this general, initially without supplies and few Continental soldiers, who gathered the troops and met the British on the open battlefield. He did not always win the battles, but he

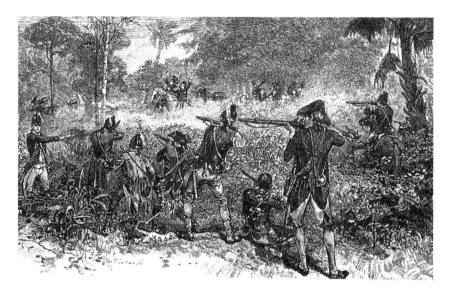

Throughout the Revolutionary War, both Continental and militia units fought in the Beaufort area. Depicted is a Continental skirmish.

kept his army together and prepared for the next encounter. This strategy of meeting the British on the battlefield, coupled with partisan raids against British communication lines and small outposts, finally swung the tide of battle in favor of the Americans.

The British leaders also helped. From an initial position of superiority, Lord Cornwallis insisted on splitting his troops, sending a good portion to the north. This was to result in the encirclement by land and sea and the subsequent surrender of his force at Yorktown, Virginia.

Remaining British and Loyalist forces in South Carolina would take refuge into the protected lines surrounding the Charles Town area where they would remain until the British evacuation of the city in December 1782.

At the formal entry of Charles Town, neither partisan units of South Carolina nor its leaders were to be represented. Now, some 230 years later, it is to be hoped that the animosities of past generations have died out. There are sufficient laurels for the brows of both Continental and militia soldiers.

THE FIRST DE TREVILLE

with Ruth de Treville Spieler

Some names run like colorful threads through the tapestry of Beaufort history: names like Barnwell, DeSaussure, Elliott, Sams and de Treville. Relatively little is known about the first de Treville to come to Beaufort, John la Boularderie de Treville—just enough to kindle the imagination. Born in New France into an old Norman-French family, he served as lieutenant of grenadiers in an English regiment in Germany (where he made the acquaintance of Cornwallis some twenty years before the two would meet again in Charles Town), and as an officer of the Continental line, until he finally met his death as the result of a duel.

Nec Spes Nec Timor (Neither Hope Nor Fear) is the motto on the de Treville coat of arms. On the shield, a crescent and three Saracens' heads indicate the participation of an ancestor in one of the Crusades. Surrounding the shield is a four-pointed coronet. In the family's possession is a ring, very old and worn, but with the coat of arms still discernable.

Various episodes in Major de Treville's life are documented in the pages of William Moultrie's *Memoirs of the American Revolution*, in records of the Continental army and in contemporary letters. Other episodes are partly shrouded by the mists of time. Members of the family have done considerable research in the European background, New France and the American colonies.

A VILLAGE NAMED TREVILLE

Some twenty-five miles northwest of Carcassonne, that great walled city of medieval France, in the Department of Aude, lies a small village named Treville. Records, however, tell that the de Treville family was originally

of Norman descent. In Alexandre Dumas' novel, *The Three Musketeers*, the commander of the king's musketeers is named Captain de Treville.

According to the *Dictionnaire Général du Canada*, Major de Treville's great-grandfather was Antoine le Poupet de Saint-Aubin, counselor to the French king and lawyer in his council. Antoine's son, Sieur Louis-Simon le Poupet de Saint-Aubin de la Boularderie, was sent to New France as a naval officer and helped found Louisburg in 1713. He was granted the island in Nova Scotia named after him—La Boularderie Island. *Nova Scotia Tour Book: An Official Guide to the Highways of Nova Scotia* describes it in the following words:

> *You are now traversing the island of Boularderie, to whom it was granted. He had distinguished himself at the defense of Port Royal* [Annapolis, Nova Scotia] *in 1707 and his son was taken prisoner at Louisburg in 1745. This island is about 30 miles long and 8 miles in average breadth. It contains more than 100,000 acres of some of the best soil in Cape Breton.*

Boularderie once described his home on the island in a letter to France: "I have in my employ 25 persons, a very handsome house, barn, stable, 25 cows and other livestock." In 1740, he wrote that he had "150 barrels of fine wheat and vegetables as in Europe, a large orchard and garden."

Following loss of the lands, members of the family scattered, some going back to France. One Lowcountry chronicle erroneously mentions that the de Trevilles came to Saint Helena Parish with the Acadians, French settlers who were exiled from their Canadian homes after the English conquest in 1763. There is no factual basis for this statement about the de Trevilles.

AS BECOMING A BRAVE OFFICER

In 1762 Europe, during the Seven Years' War (known in America as the French and Indian War), an original document was written, and it has been passed down through the years. It reads:

> *We, Otto Marquart of Pentz, Major of the British Legions and Commandant of two Battalion, do hereby attest that his Honor John de La Boularderie de Treville hath served as first Lieutenant of the Grenadiers until the reduction of my Battalion and signalized himself at different times before the enemy as becoming a brave officer but now*

finding it necessary to reduce the said battalion in consequence whereof the said First Lieutenant John de La Boularderie de Treville have received his dismission, we could not forbear giving him the best testimony of his good conduct. Dated at Munster, the 5ᵗʰ day of December, 1762, Otto Marquart of Pentz, Commandant, Mulheim adjudant.

It is unclear just when and how John la Boularderie de Treville's military career began, and how he came to South Carolina. In a letter he wrote in 1782, he mentions only that a long train of events conspired to remove him from the service of his king and country (France) and obliged him to serve the last war in Germany. Except for this brief remark, we do not know why this Frenchman fought under the English flag on German soil in the Seven Years' War.

During this period, Lieutenant John la Boularderie de Treville made the acquaintance of Lord Cornwallis, aide de camp to the Marquis de Granby, commander of the British Legion. De Treville and Cornwallis would meet again in South Carolina after the surrender of Charles Town in May 1780.

A previous commander of the British contingent was Lord George Sackville, later secretary of state for the American colonies under Lord North during the American Revolution. A French admiral, Louis-René Levassor de Latouche Tréville, commanded the *Hermoine*, which brought Lafayette back to America (to Boston) in 1780. Admiral Tréville prided himself on being the only naval commander who ever bested Lord Nelson. This occurred in 1801 during the successful defense of Boulogne.

It is not known why or how John la Boularderie de Treville came to Port Royal, South Carolina, after 1762. Perhaps he received a land grant for his services to England; perhaps he was attracted to the familiar name Port Royal, which was also the name of a seaport in Acadia.

De Treville's name first occurs in Saint Helena's Episcopal Church parish register December 27, 1778, with the recording of his marriage to Sarah Wilkinson. She was the granddaughter of Robert Wilkinson, one of Beaufort's first settlers, and the granddaughter of Thomas Burton, of Port Royal Island, also an early settler.

In the "Order Book of John Faucheraud Grimké," under the listing "A Roll of the Officers of the South Carolina Contingent Regiment of Artillery," with the dates of their commissions, we find "John de Treville, Art., to January 1777."

Colonel Isaac Hayne, who was to be hanged by the British army of occupation in Charles Town, lists in his personal record book: "Capt. Jno. La Boularderie

de Treville, Artillery, Sarah Wilkinson Spinster, Port Royal, December 1778," referring to the marriage recorded in Saint Helena's vestry book.

PALMETTOS BALK BRITISH CANNON

In the "Order Book of Captain Francis Marion," under the date of November 3, 1775, the following notation can be found: "Ordered that a man from each company with a Sergeant do go under inspection of Cadet de Treville to cut Palmetto trees for the service of the country." The logs were to reinforce the walls of Fort Johnson, in the harbor of Charles Town. They performed this arduous task well. Later, Colonel William Moultrie ordered them to do the same for the new fort to be built on Sullivan's Island, later known as Fort Moultrie.

On June 28, 1776, a British fleet was repulsed in an attack on Charles Town. Their cannonballs were absorbed or deflected by the palmetto logs. The palmetto tree thus gained its place on the state flag of South Carolina.

In early 1779, Captain de Treville was in command of Fort Lyttelton. The British had constructed Fort Lyttelton in the 1750s to protect Beaufort against attack from the south, by way of the Beaufort River. In late January 1779, while the main American and British armies maneuvered along the Savannah River, the British commander sent a spoiling attack into Port Royal Sound. On January 31, the twenty-four-gun British man-of-war *Vigilant*, with three hundred soldiers aboard, was seen approaching Fort Lyttelton from Port Royal Sound. General William Moultrie wrote that "Capt. de Treville had the command of the fort with about 20 continentals, and a number of militia; when the enemy appeared, the militia all left him; he, therefore spiked up the guns and blew up the fort." However, instead of sailing up Beaufort River, the *Vigilant* veered west up Broad River, toward Laurel Bay.

Subsequent criticism was that Captain de Treville had destroyed the fort unnecessarily. The usual court of inquiry was ordered. General Moultrie's *Memoirs* state that:

> *The Court of Inquiry, of which Major Huger is president, have reported that, on a thorough investigation of the matter laid before them, the court are of the opinion that Capt. de Treville, in spiking up the guns, and evacuating the fort, at Port Royal Island, did no more than his duty, and rather deserves praise than censure for his conduct on this occasion.*

Two days after the loss of Fort Lyttelton came the battle of Port Royal Island, in which Charles Town militia and Continentals under General William Moultrie, and some troops from Beaufort, repulsed a British advance on Beaufort from the direction of Whale Branch.

Garden's book, *Anecdotes of the American Revolution*, recounts the following episode under the title "Battle on Port Royal Island" (lately called the Battle of Grey's Hill):

> *While I mentioned the gallantry of Moultrie and of the military corps under his command, I certainly ought to have noticed the good conduct of a detachment of continental artillery, who, in no small degree, contributed to the success of the day. There were nine privates in the action, but several supernumerary officers being at the time at Beaufort, who reprobated the idea of remaining behind in such a business, they marched out with the troops, volunteering their service as private men. Captain de Treville commanded the gun carried into action; Captain Mitchell pointed it against the enemy; Lieutenant Moore applied the match and fired it; Capt. Dunham used the sponge-staff for cleaning it out. There was one other captain present, whose name is lost (probably Greyson, as he was an inhabitant of Beaufort.) Their gallantry met its reward; the gun was well served and did great execution. And great credit was allowed to all concerned for laying aside all pretensions to rank, when the cause of the country called for their services in an inferior station.*

Toward the end of his official report on the Battle of Port Royal, General Moultrie wrote:

> *I had in the action only nine continental troops; Captain de Treville, two officers, and six privates, with one brass two pounder, and only fifteen rounds, I must, in justice to them say, that they behaved well.*

WHEREVER IT MAY BE

The following weeks were marked by considerable confusion, with both armies marching and countermarching. Disasters in Georgia caused the Americans to focus their attention on regaining the upper regions of that state. Plans were made to move on Augusta, while General Moultrie and his command, including Captain de Treville, were to guard the coastal

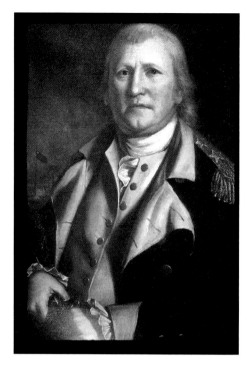

General William Moultrie often commanded the troops serving in the Beaufort area. One of his principal subordinates was John de Treville.

routes between Savannah and Charles Town. On February 9, 1779, Colonel Beekman of the Continental Artillery was "to expedite Capt. de Treville and his party, with the field-pieces, to join the army under Gen. Lincoln, wherever it may be: Captain de Treville may hear of our movements at the Two-sisters [a ford on the Savannah River north of Purrysburg]."

In John Faucheraud Grimké's order book for February 12, 1779, "at Camp, 5 miles from Purrisburgh," is the following notation:

> *The Quarter Master is to have the stores brought with Capt. De Treville's Party put to rights immediately allowing to the small gun as many rounds in its lockers as the rest. The case shot to be returned into the proper chest. What loose powder there may be in the waggon,* [sic] *must be sent to the magazine.*

The proverbial unreliability of the militia shows up in a letter by General William Moultrie, from Purrysburg, dated February 10:

Another bad piece of intelligence I am to give you, is that a whole regiment of 400 North Carolinians, say their time is out, and they intend to march this day homeward; if this would take place amongst them, as it has done with our militia, it will be of very fatal consequences to this state and the continentals that must keep the field, may be cut to pieces.

General Stephen Bull, from his "Camp at Port Royal, on February 12, 1779, wrote to General Moultrie that "agreeable to your order, the continental artillery, under the command of Capt. De Treville, marched off for the Two-sisters, yesterday afternoon, with one fieldpiece."

However, as the main American army moved toward Augusta, Georgia, the British crossed the Savannah River in force and advanced on Charles Town. The only troops standing in their way were some Continentals and militia under the command of General Moultrie. After a delaying action near Coosawhatchie, Moultrie withdrew his army to Charles Town. In order to defend the city, the Americans abandoned many of their outlying defenses, including Fort Johnson, a harbor fortification on James Island. Captain de Treville was among the troops in Charles Town. While awaiting the British attack on the city, Governor Rutledge sent an order to General Moultrie on May 16, 1779:

I request that you will be pleased to give the necessary orders for having the guns at Fort Johnson re-spiked with steel spikes [when the garrison was withdrawn from Fort Johnson they were slightly spiked with nails] *and the shot brought away to town; if time will hereafter admit of our bringing of the guns, or throwing them into the river, it will be expedient to do so; but I find this will be a work of great labor and delay; in the meantime, pray to not let us lose a moment, in doing what I now propose: it will take a very short time; and from the enclosed observations from Mr. Timothy, on the church steeple; I do not apprehend there is any great danger.*

Covered by vessels commanded by John McQueen, Esq., Captain de Treville was ordered "to proceed over to Fort Johnson, with 25 men, to bring off the shot, and spike the cannon left therein…The party to be taken from the continental troops, completely armed. [Signed] William Moultrie."

Governor Rutledge was mistaken in writing "there is [not] any great danger." In a postscript, General Moultrie noted that "this party was surprised, and some of them taken prisoners."

The British besieged Charles Town. Had they not lingered along the way, the city would have fallen. However, the Americans were given time to

strengthen their defenses, and the forces marching on Augusta were recalled and reinforced the city. The bold British thrust was repulsed.

British troops withdrew to Savannah, but they retained Beaufort as a strong point, garrisoning it with eight hundred British and Hessian regulars under Lieutenant Colonel John Maitland. It is likely that Sarah Wilkinson de Treville lived in British-occupied territory, her husband so near and yet so far away.

In early September American troops, including Captain de Treville, combined with French soldiers and naval units, besieged Savannah. Initially, the French and Americans had the advantage, but this time it was the Allies who lingered too long. Lieutenant Colonel Maitland succeeded in evading French and American blockading units and brought his Highlanders and Hessians from Beaufort to reinforce the British garrison in Savannah.

On September 5, 1779, a small party of Americans commanded by Captain John de la Boularderie de Treville captured a barge rowed by ten black men in Skull Creek, near Hilton Head Island. On board was Captain Varely, with dispatches directing Colonel Maitland to evacuate Beaufort and come to Savannah. Captain Varely tried to destroy the message, but he was prevented from doing so.

Lieutenant Colonel Maitland probably received a similar message by another messenger. He and his men left Beaufort on September 12, 1779.

On October 9, 1779, the French and Americans attacked the outer defenses of Savannah and were disastrously repulsed. Among the wounded was Captain John de Treville. The South Carolina Continentals, among whom was Captain de Treville, lost 250 men out of 600 who went into action. The French boarded their ships and departed.

A younger brother of Captain John de Treville named Ferdinand-René le Poupet de Verderonne de la Boularderie, captain in the regiments of Port-au-Prince and Martinique, was also a captain with Count d'Estaing at San Domingo and was wounded there. Was this younger brother with d'Estaing at Savannah, and did the two meet?

SURRENDER AND PAROLE

After their successful defense of Savannah, the British reinforced their Southern army, and in the spring of 1780, launched a new advance on Charles Town. The Americans, while fighting delaying actions, retreated. This time the British did not delay needlessly. On May 12, 1780, the Americans surrendered Charles Town and all troops within it. Among the prisoners was Captain de Treville.

Immediately after the surrender of the American army, Captain John de la Boularderie de Treville applied for a parole, which would not confine him to Haddrells Point, where American officers were held. He was summoned to appear at British headquarters by Captain Archibald Campbell (not to be confused with Lieutenant Colonel Archibald Campbell, commander of the Second Battalion, Seventy-first Highlanders).

The previous summer, conditions had been reversed as Captain John de Treville of the Continental artillery had taken Captain Archibald Campbell prisoner.

Application for parole had been made to Lord Cornwallis, the British commander in the Southern colonies. It will be remembered that these two had also met before—they had known each other in Germany when John de Treville had been lieutenant of grenadiers in the British Legion commanded by Marquis de Granby, to whom Lord Cornwallis acted as aide de camp.

Captain de Treville was granted a parole more liberal than he expected to receive. Now began a two-year period of travel, which took him as far north as Hillsboro, North Carolina; as far inland as Charlotte; as far east as New Bern; and from the coastal Lowcountry to the uplands, where Tories were "at the utmost of their rambling barbarity."

His adventures involved him with historically familiar names—Governor Rutledge, Colonel Mott, General Sumter and Colonel Drayton. Additional research is needed before the events may be told from their perspectives. Always in his possession were packets of letters for Governor Nash of North Carolina, verbal messages for General Francis Marion and other correspondences.

Captain de Treville was exchanged on June 15, 1781, and served until the end of the war. He was brevetted major on September 30, 1783. August 1782 found Captain de Treville at his plantation at Port Royal. Here he found his acquaintance with Lord Cornwallis criticized and suspected, and his accent was a handicap in this land of English Americans, as was his French background.

Yet, there was happiness, too, in his reunion with his wife Sarah and the birth of two children, Robert la Boularderie de Treville, born January 26, 1782, and Harriett la Boularderie de Treville, born October 7, 1783.

The first census of 1790 lists him as "Jno. Trivelle," with a family of four and twenty slaves.

The records of Saint Helena Episcopal Church for Friday, February 4, 1791, state: "Died on the 26th of January on Port Royal Island, near Beaufort, Capt. John de Treville after a long and painful illness."

Major de Treville had fought two successive duels with the same man, whose name is unknown. The following is written in *A History and Genealogy of the Habersham Family*:

An unfortunate difficulty which resulted in two duels with the same man, caused his untimely death; for though he fought first with swords and the second encounter with pistols, at the last killing his antagonist, he received a sword cut from which he ultimately died, and thus the State was deprived of this gallant soldier and member of the eminent Society of Cincinnati.

He was survived by his wife Sarah Wilkinson de Treville, a son and one daughter. A second son, John la Boularderie de Treville, was born shortly after the major's death and baptized on November 5, 1791. Major de Treville was buried on his plantation at Port Royal, now part of the Marine Corps Air Station, Beaufort.

The de Treville Monument in the St. Helena Episcopal Church cemetery.

In the churchyard of Beaufort's Saint Helena Episcopal Church stands a white marble stone marker in de Treville's memory. It reads:

A memorial to Major John La Boularderie de Treville. Born 1742 Louisbourg, N.S. Died 1791 Beaufort, S.C. Lieut. of Grenadiers under Marquis de Granby, Seven Years' War. Married 1778 Sarah Wilkinson, Beaufort, S.C. Wounded at Battle of Savannah. Member Society of the Cincinnati. He was truly a good husband, father and friend.

History records that he was also a good soldier.

PLANTATION HOMES

The view of the Southern plantation home in the popular mind is one of tall, white pillars holding up a piazza roof, with steps leading up to the main entrance. Such plantation houses existed, but they were the exception rather than the rule, especially on the Sea Islands and the adjacent mainland of South Carolina. "There were white-pillared plantation mansions, but many a planter, especially in the new regions of the old and the new Southwest, had only a rough log dwelling for a home," wrote Katherine M. Jones in her book, *The Plantation South*, published in 1957.

In the northern parts of Beaufort district, most of the plantation homes were burned by the troops of General Sherman in the first months of 1865. Some old homes have survived, especially on Saint Helena and Port Royal Islands, in the area occupied by Northern forces following the battle of Port Royal on November 7, 1861. There are also contemporary descriptions of those plantation homes to compare with present-day photos.

John Drayton, in his book, *A View of South Carolina*, published in 1802, stated:

> *Buildings, are also as various, as the values of estates; ranging in value between thirty thousand, and twenty dollars. They are commonly built of wood; some, however, are constructed of brick; principally those in cities and towns. And of late years, buildings have been carried on with spirit, throughout the state; and houses of brick and wood erected, suitable to the improvement of manners, and comforts of society. The houses are, for the most part, built of one or two stories; according to the taste, and abilities of the owner. One particularity, however, may be remarked respecting them, which is, that piazzas are generally attached to their southern front;*

as well for the convenience of walking therein, during the day, as for preventing the sun's too great influence, on the interior part of the house; and the out offices are rarely connected with the principal dwelling, being placed at a distance from it, of thirty or forty yards.

OCEAN PLANTATION

John Davis, a young English tutor for the children of Thomas Drayton, arrived in Charleston in 1798. While the family owned and also resided at the spacious Drayton Hall, near Charleston, winter months were spent at the Drayton "Ocean Plantation" near Coosawhatchie. John Davis described the latter in the following words:

> *To form an idea of Ocean Plantation, let the reader picture to his imagination an avenue of several miles, leading from the Savannah road, through a continued forest, to a wooden-house, encompassed by rice grounds, corn and cotton fields. On the right, a kitchen and other offices; on the left, a stable and a coach-house; a little farther a row of negro-huts, a barn and a yard; the view of the eye bounded by lofty woods of pine, oak, and hickory.*
>
> *Though the plantation of Mr. Drayton was immense, his dwelling was only a log-house; a temporary fabric, built to reside in during the winter. But his table was sumptuous, and an elegance of manners presided at it that might have vied with the highest circles of polished Europe…It was in the month of May, 1799, that Mr. Drayton and his family exchanged the savage woods of Coosawhatchie for the politer residence of their mansion on Ashley River.*

Building materials used in plantation homes consisted mostly of wood, which was in plentiful supply, although tabby, a Lowcountry concrete-like mixture formed of lime, oyster shells, sand and water; and bricks, both of local manufacture and imported, were occasionally used. Many of the wooden boards and planks consisted of "heart-pine" lumber, in which the pine sap had solidified, giving the wood a durable quality. Mantelpieces for fireplaces and occasional pieces of furniture were sometimes made by plantation servants, either of pine or walnut. Slave artisans, skilled in woodcarving learned in Africa, applied their talents to building plantation and town houses, although building tastes were far removed from African traditions. Beaded planks were often used inside and outside for walls, sides

and ceilings. Tongue-and-groove boards were commonly used both for walls and flooring, inside and for piazzas. Tiles placed around fireplace mantels were often imported from Europe.

THE OAKS

Johnson, described "The Oaks," a plantation on Saint Helena Island, near the bridge connecting with Lady's Island, in his book, *A Social History of the Sea Islands*, as follows:

> *The houses of the owners and overseers were usually built high off the ground. At The Oaks, one of the Pope plantations, the residence, which was just completed at the outbreak of the Civil War, is high enough above ground for the present occupant to use the space underneath as a garage. In some cases this ground floor was enclosed and made a part of the house. In such instances, the kitchen, dining room, and sometimes the sewing room were located there.*

The Oaks did not favorably impress Miss Laura Towne, a missionary from Philadelphia, who established residence there in April 1862. She described it as follows:

> *Not a pretty place, but the house is new and clean, about as nice as country-houses in Philadelphia, without carpets though, and few of the civilized conveniences. We shall have no ice all through the summer, and the water is so thick that it must be filtered, which will make it warm. That is the worst inconvenience I see.*

Mrs. Thomas Murray, mother of a companion of Miss Towne, drew a sketch of The Oaks while visiting her daughter in 1863. The drawing showed a two-story building with a piazza on both the first and second floors, and a wooden fence surrounding the yard.

THE TRESCOT HOUSE

The Trescot House today stands in The Point of Beaufort, far from its original site on Barnwell Island, near Whale Branch. The English war correspondent,

William Howard Russell, in *My Diary North and South*, published in London in 1863, wrote:

> *The planter's house is quite new, and was built by himself; the principal material being wood, and most of the work being done by his own Negroes. Such work as window-sashes and panellings,* [sic] *however, was executed in Charleston. A pretty garden runs at the back, and from the windows there are wide stretches of cotton-fields visible, and glimpses of the river to be seen.*

In 1876, the house was owned by Colonel William Elliott, who had it moved by the water to 1011 Bay Street. After its purchase by the Bank of Beaufort, it was threatened with destruction and saved by a second move, this time by land, to its present location at 500 Washington Street.

RETREAT PLANTATION

Jean de la Gaye built the Retreat Plantation house, overlooking the waters and marshes of Battery Creek, in 1745. He had moved to the outskirts of the town of Beaufort with his family from the ill-fated Purrysburg settlement of

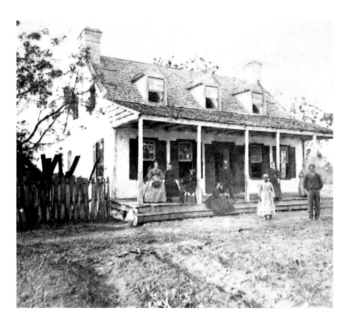

Retreat Plantation during the Civil War.

Colonel Jean Purry and his Swiss, French and Germans. A small tabby house, with two-foot-thick walls, it was restored in 1938 and enlarged in 1950 by addition of a wing. Mary Kendall Hilton, in her book, *Old Homes & Churches of Beaufort, SC*, described it in the following words:

> *The large chimneys on the east and west sides of the house have contrasting brick of a dark bluish-gray glaze inlaid in an interlocking diamond pattern. Four slender posts support the roof of a brick-floored porch considered to be a later addition.*

FROGMORE MANOR

In the 1941 *American Guide* volume on South Carolina was the following description:

> *Frogmore Plantation belonged to William John Grayson, ante-bellum writer. The White frame house has a two-story piazza supported by six columns and is surrounded by a large grove of pines, oaks, native magnolias and other trees.*

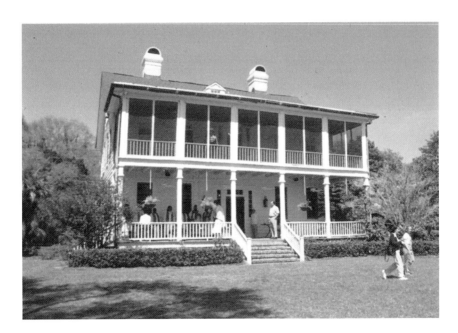

Frogmore Plantation.

Following confiscation by the national government for "non-payment of taxes," Laura M. Towne, one of the founders of nearby Penn School, purchased the property. On November 1, 1868, Miss Towne wrote:

> *I think, concerning the Frogmore house, that there is plenty of room for two good chambers over the first story, and that the roof needs altering… The house is good, sound and solid, but defective in original build as to the roof.*

Frogmore Manor, which took its name from an English country residence belonging now to the queen, looks pretty much as it did in Laura M. Towne's time. It is a peaceful place, rather far from the state road; a formal garden faces the marshes and waters. Frogmore, along with The Oaks and Retreat Plantation, remains to be seen today and gives the casual visitor insight into a society that once inhabited the Lowcountry's Sea Islands.

THE ELLIOTT FAMILY

Prominent among the families whose members helped to shape the destiny of Beaufort and the Carolina Lowcountry in the eighteenth and nineteenth centuries is the Elliott family. Its sons and daughters secured that prominence by virtue of their own talents and achievements, as well as through intermarriage with other important families, such as the Barnwells, Pinckneys, Habershams and DeSaussures.

The best known of the Elliotts include William Elliott II (1761–1808), who established the wealth of the family and is credited with the first successful planting of Sea Island cotton on Hilton Head Island; William Elliott III (1788–1863), a planter, public office holder, sportsman and author of *Carolina Sports, By Land and Water*; Brigadier General (CSA) Stephen Elliott (1830–1866), the defender of Fort Sumter in Charleston [please note that Charles Town was renamed Charleston in 1783] Harbor during the War Between the States, called by Stephen B. Barnwell "without doubt the ablest military commander to come out of old Beaufort"; and the Right Reverend Stephen Elliott, DD (1806–1866), the first bishop of the Episcopal Church of Georgia and "Presiding Bishop of the Confederate Church."

The Elliotts have left their marks on Beaufort and the Sea Islands, even though few of that name live in Beaufort today. Two Elliott houses, built by Ralph Emms Elliott and George P. Elliott, stand on Bay Street in downtown Beaufort and have been restored to their antebellum magnificence. In the churchyard of Saint Helena's Episcopal Church are Elliott grave markers, including an obelisk to Brigadier General Stephen Elliott. Elliott's Beach on Parris Island is a reminder that an Elliott plantation once encompassed a good part of that island. A portrait of Brigadier General Stephen Elliott by the Beaufort artist James Reeve Stuart is one of the proudest possessions of the Beaufort Museum.

Beaufort's Elliotts are descended from William Elliott, a Baptist (and a bricklayer, by trade), who came from Barbados in the West Indies, like many other early settlers of Charles Towne, to settle at Long Point, in Berkeley County, in the 1690s. William Elliott I (1703–1730), the son of Thomas, married Elizabeth Emms. The couple had two sons: Stephen, who died without issue, and William II, who moved to the Beaufort area and became a prosperous planter. Like other Lowcountry families, there is a profusion of identical first names in the Elliott family.

William Elliott II owned a large plantation on what is known today as Parris Island. The only remaining vestige of that plantation is Elliott's Beach, a popular swimming area for marines and their dependents. William Elliott II married three times. His first wife, Sarah Mulryne, the daughter of a Port Royal planter, died in childbirth, together with her child, on March 18, 1757. His second wife was Mary Barnwell, daughter of Colonel Nathaniel Barnwell. Through her inheritance, William Elliott II obtained another five hundred acres on Parris Island. He also owned property on Hilton Head Island and in Berkeley County. Of their five children, William III, Ralph and Stephen survived infancy. Mary Barnwell Elliott died on January 11, 1774. William then took his third wife, Mary Hazzard. For her, it was also a third marriage, having lost two previous husbands, Edward Wigg and Dr. James Cuthbert. William Elliott II amassed a considerable fortune. In latter years, he would use a "considerable part of his money to promote educational and charitable institutions and to advance public improvements." He was a member of the vestry of Saint Helena's Episcopal Church for twelve years. In colonial days, the vestry of the church performed many of the duties that today are the responsibility of county council.

William Elliott II was a commissioner of the Port Royal Ferry (located at present-day Whale Branch). While on his Georgia plantation on the Ogeechee River, he fell ill, and he was taken to Hilton Head Island, where he died on May 17, 1808. He was buried in the churchyard of Saint Helena's Episcopal Church. The inscription on his tombstone reads:

> *A man/ of integrity unspotted, of fortitude unshaken/ of understanding vigorous and correct,/ in manners yielding, in principles/ immovable! His country saw him in the field/ in early youth,/ found him in her councils/ at his last breath! A Soldier, a Citizen, a Senator/active, enterprising, just/ a Husband, a Father, a Master/ a Friend/ without weakness, without reproach/ he passed through life untouched/ by censure/ not by bending to the follies of the World/ but by living above them.*

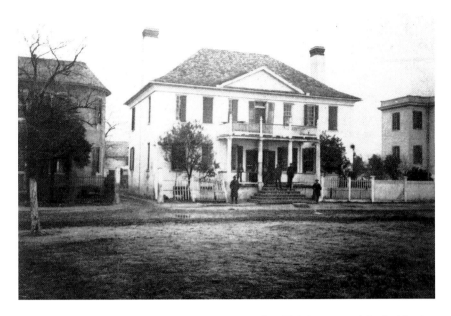

The William Elliott II House on Bay Street in Beaufort. This home was inherited by the Reverend Stephen Elliott.

According to Stephen B. Barnwell in his memorable book on the Barnwells, *The Story of an American Family*:

> *William Elliott III, even more than his father, laid the foundation for the Elliott fortune in the Sea Islands. He owned 650 acres on Parris Island inherited from his father and mother, and in 1801 bought little Newberry Plantation from Henry Middleton who had acquired it from the Bulls. In addition to these and the plantation on Hilton Head where he experimented with Sea Island cotton, he had several others in South Carolina and Georgia. His estate in 1810 shows some 160 slaves.*

There was often a close relationship between the ruling families of colonial and antebellum years. For example, William Elliott III was a member of the May 1788 South Carolina Convention, which ratified the Constitution of the United States. All of the delegates from Saint Helena Parish were related either by blood or marriage.

The most magnificent of the Elliott houses on Bay Street in downtown Beaufort was built by Ralph Emms Elliott, a son of William Elliott II and Mary Barnwell. He was born February 7, 1764. He married a distant

cousin, Susannah Parsons Savage. In 1793–94 and 1803–06, he served as a warden of Saint Helena's Episcopal Church. The family eventually moved to Savannah, but would return to Beaufort for the summers. The Elliott house, with its twelve rooms and one-foot-thick tabby walls, became the property of William Elliott III after the death of Ralph Emms Elliott on September 25, 1806. His wife had died two years earlier, and their only child, Ralph Emms Jr., born on December 11, 1793, died of malaria on November 29, 1805.

Stephen Elliott (1771–1830), the third son of William Elliott II and Mary Barnwell, was born November 11, 1771. He entered Yale in February 1788 and graduated Phi Beta Kappa in 1791, delivering the English oration entitled "On the Supposed Degeneracy of Animated Nature." Returning to Beaufort to manage the family plantations, he was married to Esther Wylly Habersham on January 28, 1796. He served in both houses of the South Carolina legislature, was a member of Saint Helena's vestry and also served on the board of Beaufort College. In 1812, he was the originator of the bill creating the State Bank of South Carolina, and he became its first president. After selling his plantations in South Carolina and Georgia, he retired from planting, having in his own words, "never been successful as a rice planter." He established residence in Charleston, "returning in summer to Beaufort."

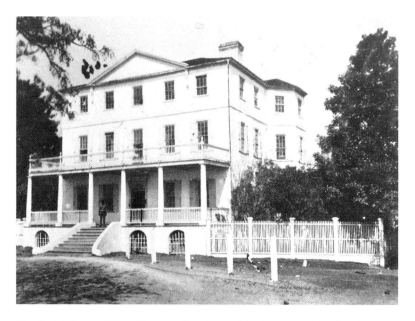

The Ralph Emms Elliott Home on Bay Street. The house was inherited by William Elliott III. It is now referred to as the Anchorage.

His studious interest in the natural sciences led to the publication of his two-volume *Sketch of the Botany of South Carolina and Georgia* (1821, 1824), which was a standard reference work for many years on the subject. His collection of insects and seashells formed the nucleus of the Charleston Museum, for which he also constructed a herbarium. He was one of the founders of the Medical College of Charleston. In February 1828, he founded the *Southern Quarterly Review*, to which he was a frequent contributor. Yale conferred an LLD degree on him in 1822; Harvard followed suit in 1825; and Columbia in 1829. Stephen Elliott died suddenly of a heart attack on March 28, 1830.

Stephen Elliott's oldest son was also named Stephen (1806–1866), and he was born in Beaufort on August 31, 1806. Possessing a keen intellect, he studied law at Harvard and South Carolina Universities; he graduated from the latter in 1825 with honors. He opened a law office some time later with C.C. Pinckney in Beaufort. Both partners of the law firm began to study for the ministry following a campaign for a religious awakening and renewal led by Dr. William Walker, of Saint Helena's Church. In 1838, Stephen Elliott became a deacon and was sent to Christ's Church at Adam's Run, near Edisto Island, but almost immediately afterward he was appointed chaplain and professor of sacred literature and Christian evidences at South Carolina College.

Following the death of his first wife, he married Charlotte Bull Barnwell on July 7, 1839. Stephen Elliott was elected first bishop of Georgia in May 1840. He was most energetic in building up his new diocese. In one year alone, 1844–45, he traveled more than six thousand miles in Georgia and neighboring Florida. Unlike many Southern contemporaries, he believed that the teachings of Christianity would ultimately lead to the peaceful abolition of slavery. Nevertheless, he committed himself firmly to the Southern cause. On April 21, 1861, he said in a sermon at Savannah, Georgia:

> *So far, we have seen war only in its pomp and circumstances divested of the terrible accompaniment of blood and slaughter. But we can hardly expect this to continue. Ere this controversy is settled we may have to endure loss and privation, disaster and reverse, from which the holiest and most sacred cause is not exempt. But He in Whom we trust will give us fortitude to endure whatever He may be pleased to send upon us.*

On March 23, 1861, Stephen Elliott joined Bishop Polk in a letter to other Southern bishops, asking them to consider their relationship to the Protestant Episcopal Church of the United States. The result was the formation of the Episcopal Church of the Confederate States. "What he helped call into being, he

supported to its end, stamping upon its work and its utterances his judiciousness and magnanimity," according to church historian William A. Clebsch.

Bishop Elliott continued his ministry after the lost war, seeking to mend broken ties by counseling the parishes of Georgia. He died suddenly in Savannah on December 21, 1866, after having just returned from a journey. "His body was borne to a grave on the banks of the Savannah, between the two states he loved best, by the vestry of St. Stephen's Church."

Stephen Elliott (1830–1866) rose in rank from captain of the Beaufort Volunteer Artillery at the beginning of the War for Southern Independence to brigadier general of the Confederate States of America. In the first months of the conflict, he placed twenty soldiers of the BVA on the tug *Lady Davis* and sent her to sea to capture a sailing vessel of a thousand tons and bring it back to Beaufort.

His report of the bombardment of Fort Beauregard during the Battle of Port Royal, which led to the occupation of Beaufort and the Sea Islands, was dated November 13, 1861. The report begins as follows: "Sir: having been assigned to the command of Fort Beauregard by Col. Dunovant, commanding the post, I beg leave to submit the following report." It closes with the words:

> *The following is a list of the wounded of the Beaufort Artillery: Capt. S. Elliott, in the leg, by a fragment of rifled gun; Sergt. B.W. Sloman, in the hand, by the same; Privates Fripp, Hamilton, Wilcox, Perryclear, and Joyce, by same; Sergeant Stuart, by recoil of columbiad; Private M.W. Fripp, by same; Private William Elliott and F.M. Murdaugh, by explosion of caisson—all slightly.*

In accordance with the strategy laid down by General Robert E. Lee, Confederate forces moved back to the mainland, content with raiding Union positions and repelling Union attacks. Captain Elliott and the Beaufort Volunteer Artillery were stationed at Pocotaligo. Captain Elliott was promoted to major after the second battle of Pocotaligo on October 22, 1862, and attached to General W.S. Walker's command as chief of artillery of the third military district of South Carolina.

On the previous August 22, 1862, he had reported from McPhersonville regarding a raid on a Union encampment on Pinckney Island, near Hilton Head Island:

> *I moved forward toward the point…up to the camp of Company H, Third Regiment, New Hampshire Volunteers, surprising them, killing according to the most careful estimate, 15 and capturing 36, 4 of whom were wounded.*

Six were seen to escape and 5 are known to have been absent. These, with the previous numbers named, give 62; the number on their morning report book. The lieutenant in command, the only officer present, either escaped or was killed. There is good reason to believe the later.

On April 14, 1863, Major Stephen Elliott reported an unusual event, "the capture of the armed steamer *George Washington* by a portion of the artillery of this command on the morning of the 9th instant." Noteworthy, too, was an act of humanity on the part of Major Elliott. The *George Washington* had been disabled by Confederate guns in the Coosaw River, between Chisolm's Island and Whale Branch (Port Royal Ferry). Major Elliott reported:

Attracted by the cries of wounded men in the marsh I entered it, but the reappearance of the gunboat rapidly approaching rendered it unsafe to remain any longer. As the wounded men had been left where they would not be perceived by the enemy and could not be assisted by us, I rode back with a flag of truce and directed the attention of the captain of the gunboat to them, and after some unimportant conversation with him returned.

On September 4, 1863, General Beauregard appointed him commanding officer of Fort Sumter in Charleston Harbor. Under his command, Fort Sumter withstood several Union landing assaults and numerous bombardments. He was wounded in the head and ankle repelling an enemy landing party on September 9, 1863. Major Elliott was wounded again on December 11, 1863, when the southwest magazine of the fort blew up. After eight months of command, Major Elliott was relieved and transferred to Virginia. John Johnson, in his book *The Defense of Charleston Harbor, 1863–1865*, stated that when Major Elliott took command, Fort Sumter was "a dismantled and silenced fort, a ruined habitation, an exposed outpost, a perilous command. He left it a formidable earthwork, armed with six heavy guns and furnishing comfortable quarters for 300 men."

Major Elliott was promoted on May 24, 1864, in Virginia, to brigadier general, and was in the lines before Petersburg when a gigantic explosion by Union sappers began the Battle of the Crater. This deep hole in the ground is still visible, after more than 110 years. Brigadier General Ellison Capers, in his *Confederate Military History* (Volume V, South Carolina), described what happened:

Two of his [Elliott's] *regiments, the Eighteenth and Twenty-second, occupied the works blown up on the morning of July 30th, and the*

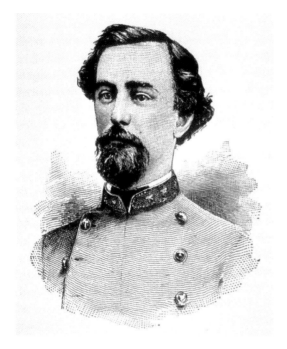

General Stephen Elliott, CSA.

immense displacement of earth which formed the crater maimed and buried many of the command. But, undismayed, General Elliott and his brigade received the onslaught made through the breach of the Confederate entrenchments.

His division commander wrote:

Brigadier-General Elliott, the gallant commander of the brigade which occupied the salient, was making prompt disposition of his forces to assault the enemy and reoccupied the remaining portion of the trenches when he was dangerously wounded.

Partial recovery resulted in his being given command of Confederate troops on James Island, near Charleston. He and his brigade participated in the retreat northward, fighting delaying battles at Averysboro and Bentonville, where he was wounded again. At the end of the war, he returned to Beaufort and to Parris Island. On the latter, where his family had owned a plantation, the freedmen were friendly, but told him: "We own this land now." Brigadier General Stephen Elliott died in 1866.

ROBERT E. LEE
IN SOUTH CAROLINA

General Robert E. Lee is best remembered for his command of the Army of Northern Virginia. In this position, he led the soldiers of the Confederate States through most of the War Between the States, until the surrender at Appomattox Court House. Less well known are his activities in one of his previous posts as commanding general of the military Department of Georgia, South Carolina and Florida from November 1861 to March 1862.

Acting within his authority as full general, Robert E. Lee organized the defenses of coastal South Carolina and Georgia. These defenses held throughout most of the war, despite Northern military and naval superiority in the Hilton Head–Beaufort enclave, which a Federal amphibious force had seized in the Battle of Port Royal on November 7, 1861. Just in time to learn of this battle, General Lee stepped off a railway car at Coosawhatchie, a small village and railroad stop on the Charleston and Savannah Railroad, where he decided to establish his headquarters.

The general was no stranger to coastal Georgia and South Carolina. In 1829–30, as a young lieutenant of engineers, he worked on the construction of Fort Pulaski, on Cockspur Island, near the mouth of the Savannah River. He was a welcome guest in the homes of Savannah residents. His father, General "Lighthorse Harry" Lee, was buried on nearby Cumberland Island, where he had died on March 25, 1818, while on a visit. During this period, 1829–30, young Lieutenant Lee paid several visits to Beaufort.

He returned thirty years later. In a dispatch to Judah P. Benjamin, Confederate secretary of war, General Lee described his situation. Secretary of War Benjamin was also familiar with the Port Royal area. The Benjamin family had moved from Charleston to Beaufort before the war, and Judah P.

Benjamin had spent many days visiting (and fishing for drum in Port Royal Sound). General Lee wrote:

> *On the evening of the 7th, on my way to the entrance of Port Royal Harbor, I met General Ripley, returning from the battery at the north end of Hilton Head, called Fort Walker. He reported that the enemy's fleet has passed the batteries and entered the harbor. Nothing could then be done but to make arrangements to withdraw the troops from the batteries to prevent their capture and save the public property. The troops were got over during the night, but their tents, clothing, and provisions were mostly lost, and all the guns left in the batteries.*

The military purpose of the amphibious landing at Port Royal was clouded in uncertainty. There was doubt whether it was necessary to organize such powerful and numerous expeditions merely to establish a base for enforcing the coastal blockade of the Southern states. Both Charleston and Savannah were exposed to attack by land, or by land and sea combined. A bold Union general might well have taken advantage of the initial confusion on the part of the Southern defenders after the successful landing on Hilton Head Island and the occupation of Beaufort.

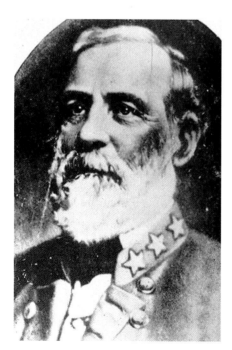

A picture of Robert E. Lee taken in 1861.

General Lee recognized the danger and described the possibilities open to the enemy in a letter to General Samuel Cooper on January 8, 1862:

I have thought his purpose would be to seize upon the Charleston & Savannah Railroad near the head of Broad River; sever the line of communication between those cities with one of his columns of land troops, and wit the other two and his fleet by water envelop alternately each of those cities. This would be a difficult combination for us successfully to resist. I have been preparing to meet it with all the means in my power & shall continue to the end.

Fortunately for the South, General Lee was not the Northern commander at Port Royal. Neither did General Thomas Sherman resemble, except in name, General William Tecumseh Sherman. The latter's troops would finally overrun the defenses General Lee would organize, but not until the closing months of the war, after W.T. Sherman's successful march from Atlanta to the sea, culminating at Savannah, Georgia.

In November 1861, General Robert E. Lee inspected the Confederacy coastal batteries and posts from Charleston, South Carolina, to Fernandina, Florida. He decided it would be futile to attempt to defend the entire coastline, but that he would concentrate on the defense of a few important locations. He outlined his plans in a letter to General Cooper, dated November 21, 1861:

The guns from the less important points have been removed, and are employed in strengthening those considered of greater consequence. The entrance to Cumberland Sound (Brunswick and the water approaches of Savannah & Charleston) are the points it is proposed to defend. At these places there is much yet to be done, but every effort is being made to render them as strong as the nature of the position and the means at hand will permit.

The change in command had prevented General Lee from taking leave and visiting his wife and family. In response to Mrs. Lee's desire to join him in South Carolina, General Lee wrote to her from Coosawhatchie on December 21, 1861, just a few days before Christmas:

I gave you the choice of Richmond too as well as Charleston & Savannah but for the threatening movements of the enemy…To reject

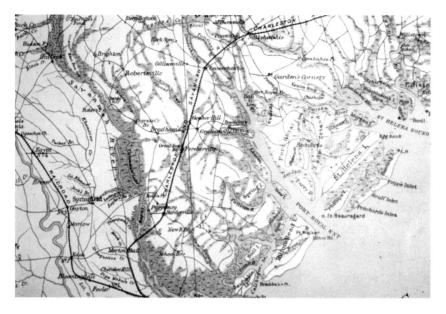

A map showing the area of Lee's command in the Port Royal district.

those agreeable cities that were accessible & select a decrepit & deserted
village because inaccessible…If you were to see the place, I think you
would leave it too. I am here but little myself.

In his capacity as commanding general, Lee also had to deal with the problems of local residents. Many residents fled the Sea Islands and Beaufort at the approach of the invading enemy, leaving behind homes, slaves and property and seeking refuge in inland towns and villages. From Coosawhatchie, he wrote on December 3, 1861, to Messieurs William Elliott, Edmund Rhett and LeRoy Youman:

I had the honor to receive the resolution passed by the citizens of the
Beaufort District at their meeting at Coosawhatchie on the 1st instant
requesting me to establish martial law on the sea coast of South
Carolina within prescribed limits.
 The present condition of things, in my opinion, does not render such a course
advisable. There is as yet no operation of the enemy to justify the interruption of
civil laws, and though many of the citizens of the State are necessarily engaged
in military duties, there must still be sufficient to attend to its civil services.

In another letter, on December 29, 1861, General Lee wrote to his son G.W.C. Lee of his thoughts about the reaction of local people to the enemy invasion:

> *I am dreadfully disappointed at the spirit here. They have all of a sudden realized the asperities of war, in what they must encounter, & do not seem to be prepared for it. If I only had some veteran troops to bear the brunt, they would soon rally and be inspired with the great principle for which we are contending.*

During these months, there were raids and alarms on both sides. Skirmishing parties from organizations like the Beaufort Artillery attacked Union outposts on Pinckney Island and raided Port Royal and Saint Helena Island to destroy plantation buildings and cotton stores. Northern troops tested Southern defenses on the mainland, protecting the railroad connecting Charleston and Savannah. On January 8, 1862, General Lee described some of these activities in a letter from Savannah to General Cooper:

> *The enemy is quiet and safe in his big boats. He is threatening every avenue. Pillaging, burning and robbing where he can venture with impunity and alarming women and children. Every day I have reports of landings in force, marching, etc. which turns out to be some marauding party.*

In the midst of preparing for enemy raids or major attacks, General Robert E. Lee found occasion in his letters to his family to comment on flowers in Savannah gardens. In a letter dated February 22, 1862, he wrote:

> *Give all my love to Charlotte. I hope her trees & flowers are all prospering. Here the yellow jasmine, red bud, orange trees, etc., perfume the whole wood, & the japonicas & azalias cover the garden.*

The period of military inactivity was coming to an end. Federal troops and ships began to be active in the waters south of Port Royal Sound. Newly freed slaves were conscripted into labor battalions. General Lee wrote to his wife Mary from Coosawhatchie on January 26, 1862:

> *There now seem to be indications of a movement against Savannah. The enemy's gunboats are pushing up the creeks to cut off communications between the city & Fort Pulaski on Cockspur Island…There are so many*

points of attack, & so little means to meet them on water, there is but little rest.

His forces, including home guard militia, never numbered as much as one-fourth of the Federal troops in Beaufort County alone, yet there was steady improvement. General Lee would not be present when Union forces launched their attack on Fort Pulaski with their new, rifled artillery. His own meager forces were always desperately short of artillery, especially heavy artillery. On March 3, 1862, he was handed a telegram from President Jefferson Davis, dated "Richmond, Va., March 2, 1862," and reading: "If circumstances will, in your judgment, allow your leaving, I wish to see you here with the least delay." To this, General Lee answered: "President Davis: If possible, I will leave Tuesday morning; if prevented, will inform you." Almost prophetically, he had written a private letter to his daughter Annie Lee the previous evening concerning the prospects in his command:

I have been doing all I can with our small means and slow workmen to defend the cities and coast here. Against ordinary numbers we are pretty strong, but against the hosts our enemies seem able to bring everywhere, there is no calculating. But if our men will stand to their work, we shall give them trouble and damage them yet.

While General Lee would go on to gain fame as the commander of the Army of Northern Virginia, the defenses started by him along the Charleston and Savannah Railroad would be held until the end of the war, stopping and damaging the numerous attacks directed against them.

CHARLOTTE FORTEN'S TALE

Charlotte Forten's story would make a good film—which was one of the reasons American Playhouse, in cooperation with South Carolina Educational Television, recently made one in Beaufort. The tale has all the necessary elements to hold viewers' attention: a pretty heroine (Charlotte Forten) facing odds in a romantic setting (Carolina Lowcountry), helping found one of the oldest schools of its kind (Penn School), leaving on account of illness and disappointments (unspecified) and a climax in which the heroine marries a man bearing a distinguished South Carolina name (Francis J. Grimké), famed minister, writer and speaker in whose blood are united two different cultures (black and white).

Born in 1848, Charlotte Forten belonged to a Philadelphia family, which was both prominent and well-to-do—and black. Charlotte was especially light skinned and has been described as a mulatto. Her grandfather, James Forten, was born to free black parents and achieved wealth in the sailmaking business; he was also active in the Philadelphia abolition movement. Charlotte's father, Robert Bridges Forten, continued the family tradition—he was a sailmaker by trade and was active in antislavery circles. Her mother died while Charlotte was still young.

EDUCATED IN MASSACHUSETTS

Robert Bridges Forten, fearing that his daughter would encounter prejudice in her native Philadelphia, sent her to Salem, Massachusetts, to be educated in its schools. There, she lodged at the home of a family friend, Charles Lenox Remond, an African American affiliated with the Massachusetts Anti-Slavery Society. Following graduation from Salem grammar school in February 1855,

Charlotte Forten decided to continue her education as a teacher in the Salem Normal School, from which she graduated in July 1856.

She began teaching in the Epes Grammar School of Salem, but resigned in March 1858 due to delicate health, which would continue to be a problem throughout her life. She returned to Philadelphia, but by 1860 she was well enough to go back to Salem to teach. In August of 1862, Charlotte Forten applied to the Boston Educational Commission and requested to be sent to Port Royal, South Carolina, as a teacher to the newly freed blacks of the Sea Islands. Although she had a recommendation by the New England poet John Greenleaf Whittier, her application was not accepted. A similar request of the Philadelphia Port Royal Relief Association was successful. On October 25, 1862, she sailed from New York on the steamer *United States*, bound for Port Royal as an accredited agent of the Philadelphia Association.

FIRST IMPRESSIONS

Charlotte Forten described her first glimpse of the South Carolina shore in her journal on October 28, 1862, as "flat and low: a long line of trees. It does not look very inviting. We are told that the oranges will be ripe when we get to Beaufort, and that in every way this is just the loveliest season to be there, which is encouraging."

The *United States* first docked at Hilton Head. Charlotte described it as "a very desolate place; just a long, low sandy point running out into the sea with no visible dwellings upon it but the soldiers' white roofed tents." The live oak trees at Brick Church, on Saint Helena Island, did impress the young teacher from the North. She wrote:

> [I] *never saw anything more beautiful than these trees. It is strange that we do not hear of them at the North. They are the first objects that attract one's attention here. They are large, noble trees with small glossy green leaves. Their great beauty consists in the long bearded moss, which every branch is heavily draped. This moss is singularly beautiful and gives a solemn, almost funereal aspect to the trees.*

THE BLESSINGS OF FREEDOM

The children whom Charlotte Forten taught on Saint Helena Island at times disappointed her and at other times encouraged her. On Wednesday, November 5, 1862, she wrote:

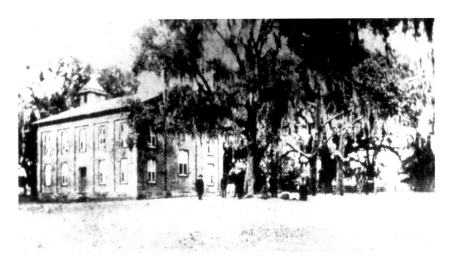

The Brick Church on St. Helena Island where Charlotte Forten taught classes to the freedmen.

I had my first regular teaching experience, and to you, and you alone, friend and beloved [her journal] *will I acknowledge that it was not a very pleasant one. Part of my scholars are very tiny, babies I can call them, and it is hard to keep them quiet and interested while I am hearing the larger ones…Well, I must not be discouraged. Perhaps things will go on better tomorrow.*

At other times, Charlotte noted:

With pleasure how bright, how eager to learn many of them seem…born in slavery, but free at last! May God preserve to you all the blessings of freedom, and may you be in every possible way fitted to enjoy them. My heart goes out to you. I shall be glad to do all that I can to help you.

The dedication to teaching runs throughout Charlotte Forten's journal. Frail and often tired, she wrote: "Let me not forget that I am not here for friendly sympathy or for anything else but to work and to work hard. Let me do that faithfully and well." There were times when the task seemed almost too much for the young, delicate teacher. On Monday, November 17, 1862, she wrote that she "had a dreadfully wearying day in school, of which the less said the better."

Charlotte Forten made the acquaintance of many of the prominent military and civilian persons living at that time in Port Royal (a term that encompassed the entire area occupied by Northern troops, including

Beaufort, its islands and especially Hilton Head, where the post office was located). The Oaks, a confiscated plantation home on Saint Helena Island, was Charlotte Forten's home for much of the time she spent in South Carolina. It was there that she wrote in her journal on November 23, 1862:

> *A yearning for congenial companionship will sometimes come over me in the few leisure moments I have in the house. 'Tis well they are so few. Kindness, most invariable,—for which I am most grateful—I meet with constantly, but congeniality I find not at all in this house.*

ENCOUNTER WITH PREJUDICE

One predominant reason why Charlotte Forten found no "congeniality" among her fellow Northern missionaries, teachers and some of the military was because, although she was young, handsome, well educated and light skinned, she was a mulatto. She found that even newly freed blacks on the islands at first had reservations about her. Laura M. Towne, founder of Penn School, noted in her diary:

> *The people on our place are inclined to question a good deal about 'dat brown gal, as they call Miss Forten. Aunt Beacky required some coaxing to wait upon her and do her room. Aunt Phyllis is especially severe in the tone of her questions. I hope they will respect her. They put on this tone as a kind of reproach to us, I think.*

Colonel Thomas Wentworth Higginson, scion of a patrician Boston family and commanding officer of a Massachusetts regiment of black volunteers, recorded that it was gratifying that the plantation people at The Oaks soon changed their attitude. He wrote that "when they heard her play on the piano, it quite put them down, and soon all grew fond of her. Miss Towne says she is the pet and belle of the island." Charlotte Forten also found friends. Returning from Camp Saxton, on Port Royal Island, on the evening of January 1, 1864, she wrote:

> *We had a good time on the* Flora. L. [Elizabeth "Lizzie" Hunn, a fellow teacher] *and I promenaded the deck, and sang John Brown, and Whittier's Hymn, and My Country 'Tis of Thee. And the moon shone bright above us, and the waves beneath, smooth and clear, glistened in the moonlight.*

WHITTIER'S "SAINT HELENA HYMN"

Following her arrival at Port Royal, Charlotte wrote to the New England poet John Greenleaf Whittier, with whom she was acquainted. She requested a poem suitable for Christmas and for her pupils. Whittier complied, sending it along with the following dedication: "Written for the Philadelphia School on St. Helena at the request of Miss Charlotte Forten, to be sung at Christmas, 1862, by John G. Whittier." The children of what would later be known as Penn School sang the words to the tune of "I Will Believe." Laura M. Towne, teacher and cofounder of the school, wrote in her diary that "the singing was only pretty good—they were too much excited." The Christmas service was held in the Brick Church, opposite present-day Penn Community Services, Inc., the successor to Penn School. The poem read as follows (it is still known and sung on Saint Helena Island):

> *Oh, none in all the world before*
> *Were ever glad as we.*
> *We're free on Carolina's shore:*
> *We're all at home and free!*
> *Thou friend and helper of the poor,*
> *Who suffered for our sake*
> *To open every prison door*
> *And every yoke to break.*
> *Look down, O Savior, sweet and mild.*
> *To help us sing and pray:*
> *The hands that blessed the little child*
> *Upon our foreheads lay.*
> *Today in all our fields of corn,*
> *No driver's whip we hear,*
> *The holy day that saw Thee born*
> *Was never half so dear.*
> *The very oaks are greener clad,*
> *The waters brighter smile,*
> *Oh, never shone a day so glad*
> *In sweet St. Helena's Isle.*
> *For none in all the world before*
> *Were ever glad as we,*
> *We're free on Carolina's shore;*
> *We're all at home and free!*

Shortly before Charlotte Forten left Port Royal for home, mainly due to her ailing health, in the latter part of May 1864, she wrote in her journal at Oliver Fripp Plantation on Saint Helena Island: "How many months have elapsed since I last communed with thee old friend, old journal. I will sketch rapidly a few of the principal events, personal, that have occurred. Some are so painful, I cannot dwell upon them."

We are left to ponder about events so painful that Charlotte Forten "cannot dwell upon them." They may have included the death of her father about that time—he became ill and died while on duty as a recruiting officer for the Northern army.

AFTERMATH

Charlotte Forten seemingly had finished her courtship with the South Carolina Lowcountry, but there was to be a sequel. In December 1878, she married Francis J. Grimké, pastor of the Fifteenth Street Presbyterian Church in Washington, D.C., and a highly respected clergyman. He was one of three sons of Henry Grimké, a member of a well-known Charleston family that also had a plantation home at Beaufort. Francis's mother was Nancy Weston, a slave belonging to Henry Grimké and maid to his wife.

Henry Grimké had two sisters, Angelina and Sarah, who left Charleston, went north and became noted for their abolitionist activities. In 1866, two of the sons of Henry Grimké and Nancy Weston enrolled in Lincoln University at Oxford, Pennsylvania. Archibald Grimké spoke there at a student meeting, and his speech was reported in the *National Anti-Slavery Standard*, where it attracted the attention of Angelina Grimké. Struck by his surname, Angelina wrote to Archibald, inquiring about his family background, and she received the following reply:

> *I am the son of Henry Grimké, a brother of Dr. John Grimké and [who is] therefore your brother. Of course, you know more about my father than I do, suffice it to say he was a lawyer and was married to a Miss Simons…and she died leaving three children viz. Henrietta, Montague, and Thomas. After her death he took my mother, who was his slave and his children's nurse; her name is Nancy Weston. I don't think you know her, but your sister Miss Ann Grimké knows her. I heard her speak of you ladies often, especially Miss Ann. By my mother he had three children also, viz. Archibald, which is my name, and Francis and John. He died about fifteen years ago, leaving my mother, with two*

A picture of Charlotte Forten later in her life.

children and in a pregnant state, for John was born two mos. after he died, in the care of his son, Mr. E.M. Grimké [Montague] *in his own words, as I heard, "I leave Nancy and her two children to be treated as members of the family."*

Sarah Grimké, Angelina's sister, wrote to Archibald and Francis J. Grimké that they were bearers of "a once honored name…I charge you most solemnly by your upright conduct & your life-long devotion to the eternal principles of justice & humanity & religion to lift this name out of the dust, where it now lies & set it once more among the princes of the land."

EPILOGUE

The two marriage partners, Francis J. Grimké and Charlotte Forten, were well suited in temperament and interests. Charlotte, however, continued to suffer fragile health. Her only child, Theodora, died in 1880 while still in infancy. Charlotte Forten Grimké died in 1914. Reverend Francis J. Grimké

retired as pastor of the Fifteenth Street Presbyterian Church in 1923, but he continued as pastor emeritus until his death in 1937. A historical marker, erected some years ago on the site of Penn School, reads:

> *After Union occupation of the Sea Islands in 1861, two northerners, Laura Towne and Ellen Murray, came to assist the freed blacks of this area, establishing Penn School here in 1862. The earliest known black teacher was Charlotte Forten, who traveled all the way from Massachusetts to help her people.*

NATIONAL CEMETERY

You've got a better looking cemetery than Arlington," remarked the labor foreman of that hallowed ground when he visited Beaufort's National Cemetery in the early 1970s.

"It's just hard work," replied Allen G. Farabee, who at that time was the Beaufort National Cemetery superintendent, having been appointed to that position in 1964. There is little doubt that it ranks among the most beautiful in the nation's 103 national cemeteries. Hard work is responsible, but also due credit are the initial excellent layout, planning and landscaping by Niels Christensen Sr.

Beaufort National Cemetery is the last resting place of between 6,000 and 7,000 Union troops. It also contains the bodies of 117 Confederate soldiers, buried in a special section. The remaining 4,000 graves hold the dead of other wars, veterans of the armed services and one crew member of a German U-boat that sank off the Carolina coast in early 1942.

Lincoln's Gettysburg Address is reproduced on a bronze plaque at the entrance of the cemetery. It is not out of place, for his words are as applicable to the Lowcountry as to the rolling Pennsylvania Dutch farmlands. Besides, it was President Lincoln who directed Major General Hunter, the commanding general in Beaufort, in a letter dated February 10, 1863, to acquire land for a cemetery site for the Union dead.

At a direct tax sale of confiscated lands, General Hunter bought sixty-five acres of land, located less than a mile north of the town of Beaufort, for ninety dollars. Niels Christensen, a young immigrant from Denmark and a Union soldier recuperating from battle wounds, was appointed superintendent of the Beaufort National Cemetery, replacing two temporary men in that post. Niels Christensen planned the cemetery, and today his planning is reflected in its general appearance.

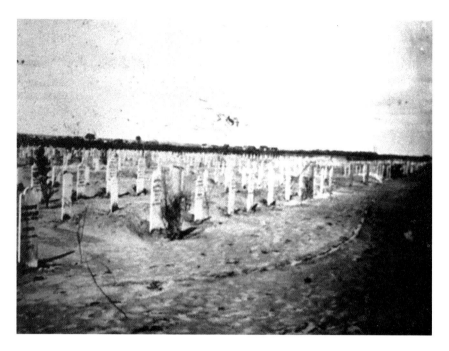

The Beaufort National Cemetery during the Civil War.

Niels Christensen married Miss Alma Holmes, of Beaufort, raised a family and became active in the business life of his chosen home. It is said that he financed the construction of the brick wall, which still surrounds the cemetery. The contractor from Augusta, Georgia, was paid by the government, but according to local lore, he neglected to repay Niels Christensen, who had advanced him the money.

In 1868, the general report of the secretary of war described Beaufort National Cemetery in these words:

> *This national cemetery is situated about three-quarters of a mile from the Beaufort River. It contains 27 1/2 aces of land; the ground is high, but only a very little rolling, and the cemetery is beautifully situated. It is surrounded by a neat picket fence, with a substantial double gate for a carriage way, on the south side, over which is erected an arch, and for foot travelers; all of which are in good order.*
>
> *The construction of this cemetery was commenced in 1863 and will be completed about the first of May 1868. The bodies interred in this cemetery, and those expected to be to be interred there, are the remains of*

deceased Union soldiers who were originally buried at the race course and at Potter's Field cemetery at Charleston, South Carolina, at Port Royal, St. Helena, Cave Island, Otter, Bray's, Paris, Henry, Morris, Edisto, Folly, James, Sullivan and Beaufort islands; also from Hilton Head and from points on the Savannah Railroad, Georgia, Pocotaligo Bridge, Stony Creek, Mitchell's place, Elliott's farm and from the Millen National Cemetery, Georgia.

The cemetery proper is laid out in the form of a half-circle, with avenues diverging from the main entrance, and with paths intersecting these avenues almost at right angles. It has also a carriage road running around the cemetery and all of the roads have been properly graded and drained. A flag staff is being erected at the main entrance and a mound is to be raised around it, ten feet high and thirty feet diameter at the base.

Following some additional description of plans, the article closed with the following: "The number of soldiers buried in the cemetery is as follows: Number known, 3,282; number unknown, 2,842; to be brought here after, 2,800. Total is 8,924."

The Beaufort National Cemetery was one of ten established within the territorial limits of the Confederacy by order of President Lincoln. The government later (in 1900) deeded thirty-six acres to the city of Beaufort, which established a municipal cemetery on part of the land. The army retained twenty-nine acres, now enclosed by the brick wall. The growing city gradually encompassed the cemetery so that it is now within the city limits, on Boundary Street, one of the city's main thoroughfares. Beaufort National Cemetery is one of the few in the country that still has space for burials, according to Superintendent Farabee.

ANY PERSON WHO HAS HONORABLY SERVED

According to present regulations, any person who has honorably served his country is entitled to burial in a national cemetery. Spouses are also entitled to burial there. Since the government allows only one site per applicant, husbands and wives are buried together, but at different levels.

In his report for May 1977, Superintendent Allen G. Farabee listed 11,189 gravesites used and 5,845 gravesites still available. Original legislation signed by President Lincoln on July 17, 1862, provided

that the President of the United States shall have power, whenever in his opinion it shall be expedient, to purchase cemetery grounds and cause them to be securely enclosed, to be used as a national cemetery grounds for the soldiers who shall die in the service of their country.

In 1873, Congress extended national cemetery burial rights to all honorably discharged Union Civil War veterans, and new cemeteries were established. The same year marked the replacement of the standard wooden grave board with the present stone marker.

In 1948, Congress broadened burial rights to include all honorably discharged veterans, United States citizens who served honorably in armies of allied nations and veterans' spouses and children. In 1959, Congress granted burial rights to reservists and members of the National Guard who died under honorable conditions while serving active duty.

Almost from its beginning, Beaufort National Cemetery has been the scene of impressive annual ceremonies on Memorial Day. Traditionally, this is one of the chief holidays of the black community. Prior to Memorial Day, each one of the more than ten thousand graves is decorated with a small American flag. In recent years, the Sons and Daughters of the Civil War and the Women's Relief Corps sponsor memorial services for those who died for the Union. Declining attendance during past years led to a determined, successful effort by civic groups and Beaufort County Council under the direction of Councilman William Grant. Memorial Day 1977 saw thousands of spectators and participants in Beaufort, highlighted by ceremonies in the national cemetery.

One section of the cemetery contains grave markers with the inscription "USCT" (United States Colored Troops), a reminder that Beaufort's men were divided in loyalties during the War Between the States. Here, on the Sea Islands, the first black troops were enlisted into the Federal ranks.

Some four thousand stone markers in Beaufort National Cemetery bear the simple inscription "Unknown Union Soldier." Others bear inscriptions that testify to the history these men helped form. The oldest date of death in the cemetery is probably the following:

Sacred to the memory of Elias D. Dick, Late Capt. 18th Regt. U.S. Inf. Who died at Fort Johnson 4th June 1815 in the 26th yr. of his age. As an officer, he was respected. As a man he was possessed of the most benevolent humanity. Just and upright in all his transactions, of a soul sincere, & died deservedly regretted.

One child's grave marker reminds the visitor that, at one time, the best way to reach Beaufort was by ship, on what was often a hazardous voyage:

Sacred to the memory of William Benjamin, son of Capt. J.M. & Sophia Hill, U.S. Army, who died at the age of 1 year and 4 months on the morning of the 30th of Sept. A.D. 1840 on board the ship LaFayette *on the passage from New York.*

Three markers with similar inscriptions tell of a spirited and deadly naval engagement. The first reads:

The grave of Gerd Reussel in the Beaufort National Cemetery.

Sacred to the memory of Joseph Phillips, Ordinary Seaman of the U.S. Steamer Marblehead, *who fell in action on the Stono River, Dec. 25, 1863, gallantly battling for his Flag and Country.*

The inscription on one grave marker is entirely in Spanish and is remembrance of the officer of a Spanish merchant ship who died while his vessel was at Port Royal. It reads:

Don Saturnio de Echevarrio Q.E.P.D. Anzero de Capelastequy Doman de Asqueta ofiales del Vapor Espanol 'Pedro' y en memoria de su desconsollada Esposa, dedican este triste memoria recuredo a su Capitan, fallecido en este Lazareto el 22 Octubre 1886.

Attesting to the perils of U.S. Marine Corps training on Parris Island is one grave inscription reading:

Harry F. Talbott, Co. A. USMC Enlisted Dec. 12, 1907. Drowned in the line of duty at the Marine Officers School, Port Royal, S.C. Feb. 15, 1909.

GERD REUSSEL OF THE *KRIEGSMARINE*

One simple marker bears the name Gerd Reussel and the date May 9, 1942. On Memorial Day 1977, this marker, too, was decorated with an American flag. On May 9, 1942, the U.S. Coast Guard cutter *Icarus*, cruising off Cape Lookout, North Carolina, at five in the afternoon, encountered a German U-boat, the *U-Rathke*, and forced her to surface. There was an exchange of gunfire and the U-boat was sunk. Thirty-three members of its crew were rescued. Twelve of the U-boat crew went down with their ship. One of those rescued had suffered a leg wound and died on the way to Charleston.

The thirty-two survivors were held in an American prisoner of war camp until after the war, when they were returned to Germany. The dead crew member, Machinist Mate Gerd Reussel, was buried in the Beaufort National Cemetery. Lieutenant Commander Maurice D. Jester, commander of the *Icarus*, received the Navy Cross.

Among the crew of the *Icarus* was Allen G. Farabee who later became the superintendent of the Beaufort National Cemetery, in which Gerd Reussel of the German *Kriegsmarine* is buried.

WHAT IS
"BEAUFORT STYLE"?

The "Beaufort Style" refers neither to mode nor manners, but to an architectural form distinctive to Beaufort, South Carolina. It differs from the prevailing architecture of Savannah, Georgia, as well as that of Charleston, South Carolina, but is more easily recognized than described. The *1979 Beaufort Preservation Manual*, prepared for the City of Beaufort by John Milner Associates, stated:

> *Beaufort's typical residential architecture, with its raised first floor, double porches, southern orientation, high ceilings, and shallow hipped roof, is a design that persists throughout the City's entire history. Yet there is no universally recognized architectural term for this style. Consequently it is important to investigate specific details and proportions to aid in stylistics description.*

The Beaufort Style came to flower during the Federal period, roughly from 1790 to 1830. Before those decades, the houses of Beaufort were relatively simple, of frame construction, single pile in depth, had a hipped roof with chimneys on the east and west and a center entrance protected by a single piazza, and were usually built on a tabby foundation.

Between 1850 and 1860, Greek Revival mansions—more elaborate, built of brick or tabby in addition to wood—were constructed mostly on Bay Street and The Point. These, too, retained traditional Beaufort Style elements, which may have been introduced to the Beaufort area by early settlers from Barbados.

The *Beaufort Preservation Manual* described the Beaufort Style of the Federal period as based on the Palladian concept of triadic rhythms, delicate details and harmonic proportions (principles tempered by a continued conservative

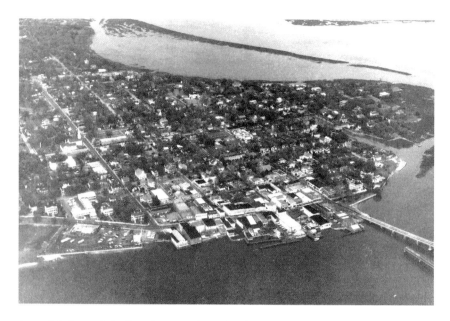

An aerial photo of the Beaufort waterfront showing the southerly orientation of the town's early houses.

approach to construction and a restrained use of the delicate Adamesque detail). These were two- and two-and-a-half-story, five-bay homes, and they featured the hipped roofs and raised basements used earlier.

> *More often than not, the major new feature was a projecting portion…in the form of a frontal, two-stage porch. It provided a feature in which Orders would normally have been superimposed (using the Doric on the first floor and the Ionic on the second floor, as an example). But, in Beaufort a simpler variation occurred and the Doric Order was used at each floor level with a differentiation in the size of the columns serving to identify each level.*
>
> *Built of tabby and heavy timber frame, these Palladian structures featured four rooms to a floor. While the traditional rear "T" ell provided this space in some examples, others used the double-pile plan, which had been used but not popularized before the war. For either plan, interior chimneys rose between the south and north rooms.*

Examples of the Beaufort Style houses of the Federal period in Beaufort include the following:

Robert Means House (ca. 1790), 1207 Bay Street
Blythewood House (ca. 1815), 711 Prince Street
de Treville House (ca. 1785), 701 Greene Street
Reverend Henry Ledbetter House (ca. 1805), 411 Bayard Street
Talbird Sams House (ca. 1786), 313 Hancock Street

The Robert Means House is typical of the Beaufort Style. The structure has a two-story veranda, a high-arcaded basement and double entrance stairs. The house retains its original Adamesque woodwork and mantels in the two front rooms on the first floor. The double front steps found in this house and other Beaufort homes are locally known as "Friendship Steps."

In 1965, Captain Evan Edward Fickling wrote that the Blythewood House was

> *a three story clapboard building, the foundations and ground story and walls being of "tabby" construction…The extensions of the roof over the front porch, and the balcony porch, are supported by slender, tapered wooden columns, square in cross-section, hipped at the bottom on the lower porch and all now painted black.*

Like many Beaufort houses, it is set in a large garden.

The de Treville House has had few basic architectural changes since its construction around 1785, except for the addition of indoor plumbing,

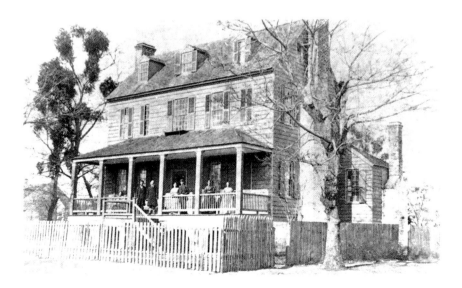

The de Treville House.

electricity and an indoor kitchen. Its halfway room suggests that there was a Palladian window in earlier days, as seems to have been the case with other Beaufort Style houses of the Federal period. A back piazza was later enclosed and became a dining room. Rooms on either side of the dining room are now a study and a kitchen, respectively. The three-story house, with five dormer windows, is set on a tabby foundation, while the piazzas are set on arcaded brick foundations.

The Reverend Henry Ledbetter House, according to the guide, is an "excellent Beaufort Style house with…a two-story veranda which extends halfway along two sides of the house. It has good inset chimneys, a fine hipped roof…The interior features eight mantels, good wainscoting, deep cornices, and an original ceiling medallion." Mrs. Helen Burr Christensen, who owned and lived in the house for many years, said that the house originally had only one porch in the front, but was changed, as was the case with the de Treville House and others.

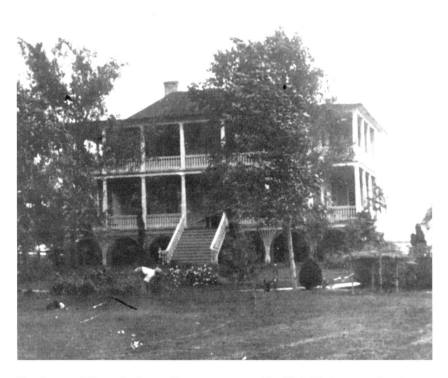

The Reverend Henry Ledbetter House as renovated by Niels Christensen after the Civil War.

HOW TO BE CONVERSANT IN THE BEAUFORT STYLE

In Beaufort, owners and admirers of antebellum homes seem to delight in interspersing even casual conversation with technical architectural terms, putting most people at an immediate and distinct disadvantage. There are basic architectural definitions, as well as some specific Beaufort terms, which will help in the understanding and appreciation of Beaufort's distinct architectural style.

Adam style (or Adamesque): an eighteenth-century English architectural mode whose decorative motifs include alternating squares and circles, fans and half fans and intersecting curves.

Arcaded: a series of arches and connecting columns often, in the Lowcountry, forming the ground floor or basement on which the house rests.

Arched caps: chimney coverings in arched forms to prevent rainwater from entering chimneys and fireplaces.

Beadwork: projecting ornamental molding in the form of a rim, or band, found on walls, paneling and woodwork.

Capital: the upper part of a column, usually decorated in one or more of the traditional Greek styles. Each floor, however, has capitals of only one style.

Clapboard: narrow wooden boards, usually thicker on one edge than the other, found commonly in exterior siding in an overlapping arrangement. Clapboard sometimes is "beaded," with a rounded edging trim of the lower edge.

Columns: round wooden or stone pillars supporting the ceilings of piazzas. Columns are divided into three parts—shaft, capital and base.

Dormer: a window set vertically in, and projecting partly out, of the roof of a house. The name is also applied to the portion of the roof containing such a window.

Fanlight: a semicircular window, often above a door or another rectangular window. Radiating sash bars resemble the ribs of a fan (or, in the Lowcountry, a palmetto leaf) giving the fanlight its name.

Georgian: a British architectural style developed during the reigns of George I through George IV (1714–1820). The use of mahogany was introduced in the middle of the Georgian period. The style is often associated with Palladian motifs.

Lace brick: brick walls, which have bricks laid so as to allow open spaces on sides, top and bottom.

Mantel: the brick, stone or wooden beam serving as a lintel, which supports the masonry above a fireplace. It may also include the shelf above the fireplace and the supporting portions from floor to lintel.

Medallion: a panel in a wall or ceiling that is ornamental relief in design and often made of plaster. From the center of a medallion, a chandelier is often suspended from the ceiling.

Palladian: an Italian Renaissance style characterized by arched openings resting on columns. Palladian doors and windows are usually flanked by two narrow openings, square on top and the same height as the columns.

Piazza: colonnaded and arcaded porches that protect the house from the summer sun and heavy Lowcountry rains, as well as providing space for relaxation "BT" (before television). *Piazza* is Italian for "porch."

Tabby: a distinctive Lowcountry building material composed of equal parts of lime (made of burnt oyster shells), sand, more oyster shells and water. The use of tabby often dates a building (pre-1850).

A noticeable difference in architectural styles that distinguish Beaufort houses from those in Savannah and Charleston is the spaciousness characterizing those in Beaufort. The latter are often set in open garden spaces, originally with one or two houses to a block, except on Bay Street and perhaps the lower part of Carteret Street.

BAY STREET

Beaufort's Bay Street is the equivalent of Main Street, USA. It is unusual, however, in that it combines a number of characteristics not often found together. The business district is concentrated in a three-block area between Carteret and Charles Streets. To the east of Carteret Street is one block of residential homes on the north side, and a park and an old concrete/tabby sea wall facing the Beaufort River. To the west of Charles Street are the South Carolina National Bank, the elementary school and private homes, many dating from antebellum times.

On the Beaufort River side, the business district fronts along the Henry Chambers Waterfront Park. To the west, the park adjoins the Beaufort Marina. Since its initial development around 1717, Bay Street has maintained its partly commercial and partly residential qualities, even preserving some of the eighteenth-century property lines and some of its old mansions, as well as the original street alignment.

Some old buildings can still be found on Bay Street, between Charles and Carteret (John Cross Tavern, Bay Street Trading Company, John Mark Verdier House, Habersham House), but most of the storefronts date from 1950, with some circa 1880 examples still very much evident. According to the John Milner Associates' *Beaufort Preservation Manual*:

> *New construction of commercial buildings on and near Bay Street has generated more local variations of neo-Georgian detail than good contemporary designs, but in each, there has been a noticeable attempt to conform either to historic materials or rhythms.*

Although the town of Beaufort dates its beginnings back to 1710, the first land grants were not recorded until 1717. According to the Milner study, "twenty-four

lots of lesser size, presumably planned for commercial use, were sited on the north side of the unnamed street to the river" even before the 1717 date.

Henry A.M. Smith, in his 1912 article entitled "Beaufort—the Original Plan and the Earliest Settlers," describing a circa 1716 map, wrote that "the street or space along the water front is not designated by any name on the plan. In the grants and some deeds giving the boundaries of the front lots this street is called Bay Street, or The Bay."

The lot numbers on the circa 1716 map started on the northeast corner of Bay and Charles Streets, running from one to fourteen at Carteret Street and continuing from fourteen to twenty-four to East Street.

A 1729 map of Port Royal by Captain John Gascoigne depicted two forts on the waterfront. One fort, with four bastions, was located on the bay, near Scott's Street. The other fort was near the location of the present-day county courthouse, with two bastions to the south and a brick (or tabby) wall on the north.

The Milner study stated that, in the 1760s, "early Beaufort by this time was essentially a commercial town where merchants and factors, intent on making the most of diversification, traded local crops for tools and household goods." There were at least three dry goods stores on Bay Street, and the wharfs nearby served ships, connecting Beaufort with the larger cities of the coastal colonies.

By the 1790s, according to the Milner study, Beaufort

> *had a population of only two hundred, but its smallness belied its importance. It was recognizable both as a port and as a resort and most of the town's built-up area was concentrated near the waterfront where the newer mansions contrasted in personality and size with the more utilitarian warehouses, taverns, and shops. The local artist who visualized the scene in 1798 depicted these contrasts of scale and density.*

The "local artist" of 1798 is not known; the original painting has disappeared, but a copy exists. It showed the waterfront side of Bay Street, as seen from a vantage point on Lady's Island from White Hall, or nearby.

THE SEA WALL

In October 1855, property owners Matilda Fowles, Sarah B. Stoney and William A. Morecock deeded to the Town of Beaufort waterfront portions of their land on which town officials were having constructed a sea wall (which still stands, east of the approach to the Lady's Island Bridge).

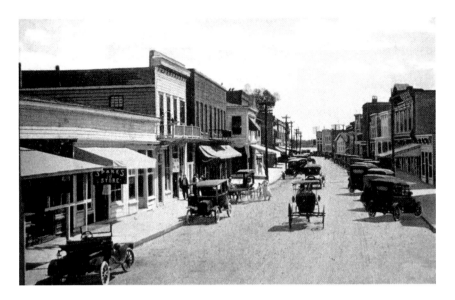

A view of Bay Street looking east from Charles Street in the early twentieth century.

The deeds specified that the wall and street were to be for the uses of the Town of Beaufort, and

> *remain under control of the Town Council and their Successors as long as there was no change—no fences, wharves, buildings or constructions of any kind shall be erected or maintained...excepting such boat houses as it may suit the Proprietors of said lots to erect.*

Today, Beaufort's first waterfront project is maintained as a small public park. The sea wall, built in 1855, continues to serve its original purpose—"erection of said wall is intended by the said Town Council directly for the benefit of the town and indirectly for the benefit of the Proprietors of the adjoining lots."

BAY STREET HOUSES

Excellent examples of buildings (still standing) of the Federal period are the John Mark Verdier House, and just across Bay Street, the Saltus/Habersham House. Another building of note, the John Cross Tavern, may have an even earlier construction date, around 1730. One may assume that the buildings constructed before 1800 had piers and warehouses on the south side of Bay Street.

THE JOHN CROSS TAVERN

In her 1937 booklet on Beaufort homes, Mrs. Lena Wood Lengnick wrote:

> *Butler's cafe, in Beaufort's earlier days, was the site of a tavern called John Cross's Tavern. The dock nearby was also called by the same name. John Cross is mentioned in the minutes of St. Helena's vestry book in 1802, the procession of over 200 gathered at John Cross's Tavern to walk to the site of the new college. At this tavern John Wesley spent the night. Pirates also raided it. This information was gathered from a set of old histories owned by Mr. S.H. Rodgers and unfortunately destroyed by fire.*

THE JOHN MARK VERDIER HOUSE

The John Mark Verdier House was built between 1795 and 1800 in the then-popular Adams style. The home of a prosperous Beaufort merchant, John Mark Verdier, it was constructed by Messieurs Converse and Fish, both from the North. An obituary on April 19, 1815, in Charleston's *City Gazette* read:

> *Departed this life, at Beaufort, S.C. on the 10th inst. Mr. Nathaniel Converse, a native of Massachusetts, but for the last fifteen years a resident of this town.*

The house was both Mark Verdier's family residence and his business office. It is doubtful, however, that he actually owned ships to carry his products and imports to and from Beaufort. An 1825 visit by the Marquis de Lafayette was marked by a celebration by the town's residents. A committee composed of Dr. James Stuart and Messieurs John A. Stuart and Richard de Treville welcomed Lafayette. Following a speech by Lafayette from the house balcony, the Verdier House was popularly called for many years "the Lafayette House."

The John Mark Verdier House was condemned by the city in 1942, but saved from destruction by the Committee to Save the Lafayette Building. Members included John F. Morrall, Howard E. Danner, Mrs. Allan Paul, Mrs. Chlotilde R. Martin, W. Brantley Harvey, J.E. McTeer, Mrs. Rivers Yarn, Mrs. Gus Frank and Meyer Schein.

The John Mark Verdier House in the mid-twentieth century.

THE SALTUS HOUSE

For many years the house at 802 Bay Street was referred to as the Habersham House, but recent research has shown it to be more rightfully termed the Captain Francis Saltus House, built in 1796. Evidence points to a boatyard built behind the house where five gunboats were constructed in the early nineteenth century for the United States Navy. In the twentieth century, the house was used as a store, and in the 1950s, when it was used as a Belk Department Store, the entire first floor's walls were removed and an addition was placed on the riverside. Some architectural historians claim that the building is the nation's only surviving three-story, tabby single house.

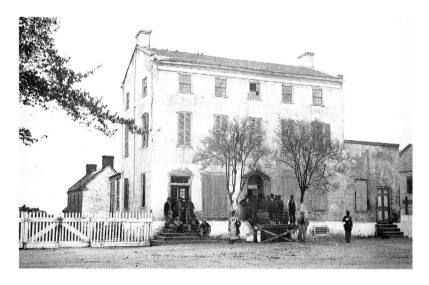

The Bay Street side of the Francis Saltus House in 1864.

THE THOMAS LAW BUILDING

Abraham Cockcroft built the Thomas Law Building at 920 Bay Street before the War Between the States, following destruction by fire of a Barnwell house, built in the 1790s. The Cockcroft family abandoned their home when the white population of Beaufort evacuated town following the Battle of Port Royal on November 7, 1861. The building was shown in an artist's drawing in *Leslie's Illustrated Weekly*, in November 1861, depicting ranks of Union troops, the Fiftieth Pennsylvania Volunteer Regiment, marching down Bay Street toward the Point, led by General Isaac Ingalls Stevens on horseback. From 1868 on, the building was known as the Beaufort Customs House, since Beaufort was a port of entry with its own collectors of customs. One collector was Robert Smalls, wartime hero of the *Planter* and a prominent black political figure of Reconstruction days.

COMMERCIAL EXPANSION ON BAY STREET

The *Beaufort Preservation Manual* stated:

> commerce expanded along the riverfront so that by 1884, both sides of
> Bay Street were entirely built up. Wharfs and warehouses occupied the

land nearest the river; the buildings facing the street were occupied by grocers, jewelers, offices and dwellings. At the end, near Charles Street, was a cotton gin. The Palladian mansions built on Bay Street before 1820 served partially as commercial structures.

Cotton gins also existed on the north side of Bay Street between West and Scott Streets and Carteret, near Port Republic Street. A concrete sea wall, ten feet high, extended along the river from Carteret to New Street, providing a rigid waterside edge for the mansions in the 600 block of Bay Street.

The impact of commercialism on the town was not only underscored by the proliferation of wharfs, cotton gins and other mills, but also by the hotels, guesthouses and banks that occupied former homes on Bay Street. The renovated hotels were near the waterfront, essentially blocking service structures, icehouses, shanties, sheds and African American tenements, all of which were close to the surviving eighteenth-century homes.

THE SEA ISLAND HOTEL

The best known of the town's hotels was the Sea Island Hotel, at the corner of Bay and Charles Streets, where the Sea Island Motel (which took its name from its predecessor) is situated today. From the 1870s to the 1920s, the Sea Island Hotel was host to many visitors and the scene of many social events. A bathhouse, on the Beaufort River, was part of the property and one of its attractions.

Erected by George Moose Stoney as a family residence before the Civil War, the house was purchased by Nathaniel B. Heyward. Direct tax commissioners sold it to the government during the war "for non-payment of taxes." General Rufus Saxton reportedly acquired it for $1,000 and sold it in 1872 to Azubah G. Kingman for $5,000. An 1874 deed mentioned that "the said premises being the same on which stands the Sea Island Hotel." In 1919, the National Catholic War Council bought the Sea Island Hotel property from Alice F. Odell. The council retained title and use until 1926 when Mrs. Mary A. Polk acquired title to the property.

BAY STREET:
Nineteenth and Twentieth Centuries

The existing business section of Bay Street, between Carteret Street and Charles Street, was first developed in the period between 1865 and 1893;

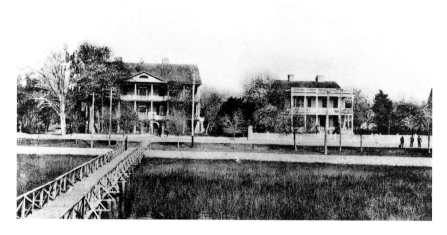

The Sea Island Hotel and Trescott House on Bay Street in the early twentieth century. The Sea Island Hotel was demolished for the current Sea Island Motel, while the Trescott House was moved to 500 Washington Street.

the latter was the year of the big storm. According to the *Beaufort Preservation Manual*, the docks and warehouses were nearest the Beaufort River

If one were to stroll along Bay Street in 1972 (and still today), one could not fail to note the striking difference in the appearance of many buildings between the first and second stories. Attempts were made to modernize the street level, or first story, but the nineteenth- and even eighteenth-century origins of a building are often apparent in its second story The old Belk-Simpson (Saltus/Habersham Building) was a good example of such alteration.

It would be incorrect to say that Bay Street in the old days was always bustling with activity, economic or otherwise. In a visit to Beaufort, about the year 1873, Edward King described his initial impressions in his book, *The Great South*, published in 1875:

> *The long street by the waterside, in Beaufort, was as still when I entered it as if the town were asleep. The only sign of life was a Negro policeman, dressed in a shiny blue uniform, pacing languidly up and down. But there was not even a dog to arrest. On the pretty pier in front of the Sea Island Hotel two or three buzzards were ensconced asleep; half across the stream a dredge-boat was hauling up phosphate from the channel-bed.*

COMING OF THE IRON HORSE

The railroad company seeking to construct the railroad line from Augusta, Georgia, to the town of Port Royal sought to lay the tracks along the banks of the Beaufort River, within the Beaufort town limits. The attempt failed, due to strong opposition led by members of the Beaufort town government. The railroad was built along the western portions of Port Royal Island, near the marshes. That, too, caused some problems, as is apparent in a 1891 newspaper clipping, quoted by Chlotilde R. Martin, in one of her 1941 newspaper columns:

> *Beaufort has perhaps more antiquated carriages, rattletrap family arks, and rheumatic buggies than any town of its size in the state. Last week, we had the pleasure of stepping off at the Beaufort depot and we found fourteen drivers clamoring for the patronage of two passengers.*
>
> *A pretty shell road nearly two miles long leads to the business part of the town. The owners of this road charge the hackman seventy-five cents a week for toll fare. The hackman charges twenty-five cents fare from the depot. While they squabble and fight for a passenger, they unite against a reduction of rates.*

One should bear in mind that the depot mentioned in the 1891 article was the old railroad station at the end of Depot Road. In those days, as many as a half dozen trains arrived and left Beaufort (and Port Royal) daily. In addition, both Charleston and Savannah could be reached by ships, which made Beaufort a regular port of call. As late as 1941, the South Carolina volume of the American Guide Series, in its description of Beaufort, listed the railroad station at the west end of Depot Street, for the Charleston and Western Carolina Railway The bus station was on Bay Street, between Scott and West streets, for the Greyhound Lines. Ships' piers were listed as being on Bay Street, between Scott and West streets, for Beaufort-Savannah Steamship Lines, with fares to Savannah costing one dollar and three round trips running weekly. Between Carteret and Charles Streets were "piers for travelers using the Intracoastal Waterway." The Beaufort Savannah Steamship Line operated as early as 1909. Bluffton was one of its scheduled stops; elsewhere, the ship would stop whenever a rowboat was sighted, bearing a prospective passenger, to take him aboard.

BEAUFORT STREET PAVING

For a long time, Beaufort streets were not paved, consisting only of the native sand, which was often ankle deep and treacherous during heavy rains. Sometimes there would be a layer of crushed oyster shells on them. One may still see the designation "Old Shell Road" on street signs near the U.S. Naval Hospital. Eventually, some of the main streets were paved with bricks.

An old-timer informed this writer that the first street in Beaufort to be paved with bricks was the east end of Bay Street, probably in 1916 or 1917. In 1939, maintenance on some streets, including Bay Street, was taken over by the State of South Carolina from the city. In her Charleston newspaper column, Chlotilde R. Martin wrote:

> *The state highway has taken over Boundary, Carteret and Bay Streets in Beaufort, it is understood, and the report is being circulated that the bricks on Bay Street and probably some of the trees are to be removed to make way for this so-called progressive act.*
>
> *From inside information, it has been ascertained that the old-fashioned brick paving is definitely to go and authorities have promised not to remove any more trees than are necessary.*

1920S ECONOMY AND BAY STREET

In a speech by James G. Thomas to the Beaufort County Historical Society on July 25, 1985, Mr. Thomas stated that:

> *The 1920s decade was a very interesting time in the history of Beaufort. There were good times and there were bad times, and we date the climax as July 10, 1926. The beginning of this period was a very prosperous time for Beaufort.*
>
> *The economy was based mostly on agriculture. There was a naval prison on Parris Island. The Recruit Depot was very small at that time. The farmers were basing the economy on truck farming, and the predominant vegetables were the Irish potato and lettuce. The farmers were making so much money in the early 1920s that Mr. Lea, Mr. McLeod and Mr. J. R. Bellamy bought large houses on Bay Street and moved into town from their farms.*
>
> *Most of the businesses were in the three blocks of Bay Street between Carteret Street and Charles Street. Most of the stores on the north side*

of the street had tin awnings, but the tin awnings disappeared during the '20s and were replaced with canvas awnings.

FIRES ON BAY STREET

The wood construction of many old Beaufort buildings and the fierce summer heat, which dried out boards and beams, together with inadequate heating equipment for the colder months, caused fires, some of which were quite destructive to houses and business establishments on Bay Street.

On January 20, 1907, State Senator Niels Christensen wrote from Columbia, South Carolina, to William Ohlandt, in Beaufort:

> *Say; Will, that was game of you to think of me and to wire me when your home and store was burning to the ground…I stayed up in the State office until after midnight reading the dispatches and it seemed to me your firemen did splendid work to hold the conflagration at Mrs. Levins. How you saved Chin Sang; and the* Gazette *building I don't see. With the best part of three blocks burning you must have had to fight at many points, and I wish I could have been there to fight with you all.*

The *Beaufort Gazette* reported another major fire on Bay Street on June 4, 1925:

> *Scene of ruins left in wake of fire which ravaged blocks on riverside of Bay Street between West and Scott streets, during the early hours of May 26th. The Roberts buildings, containing the River View Hotel and the Austin Grocery Company; and the Lengnick building, containing the department store of E.E. Lengnick, were completely destroyed. The building of Claud M. Aman was so badly damaged that it will have to be torn down. The estimated loss totaled $75,000 with only $16,500 worth of insurance outstanding.*

THE BEAUFORT GAZETTE

One of the business establishments on Bay Street for many years was that of the *Beaufort Gazette.* It occupied different sites at various times. On February 28, 1907, the *Gazette* reported one move into new quarters:

The property at the end of Bay Street, formerly owned by the Verdier estate, has been purchased by N. Christensen & Sons, and the building used as a law office has been enlarged and fitted up for the Gazette *offices.*

At another time, the *Gazette* was located on the Bay Street waterfront, in two little rooms in the back of a building located in the rear of the old First Federal Savings & Loan building. Used as a cotton gin, it was owned by William Waterhouse, who had purchased the *Gazette* from Colonel William Elliott.

Later, the *Beaufort Gazette* was quartered in the Lafayette Building (John Mark Verdier House) on Bay Street, on the first floor of the east end. In 1922, the newspaper reported:

The future home of the Gazette *will be at the corner of Bay and Charles Street, where enough floor space is to be had to take care of the equipment and leave sufficient room for offices for the Chamber of Commerce and the* Gazette.

HURRICANE OF 1893

Aside from the dangers of fire, Bay Street merchants and house owners also suffered from occasional storms and hurricanes, which struck the Carolina coastal region. On September 2, 1893, the *Savannah Morning News* reported:

At Beaufort the damage done was tremendous. The entire business portion of the town is wrecked. Every wharf and warehouse is gone and the stocks in nearly every store damaged. The storm took off nearly every roof, while the heavy rains which have fallen since Monday leaked into the stores and ruined thousands of dollars worth of goods.

BAY STREET BANKS

Until recently, almost all Beaufort banks had their main offices on Bay Street. Beaufort's first bank was a branch of the Freedman's Savings and Trust Company, better known as the Freedman's Bank. Established by Congress in February 1865, the bank was to be exclusively for blacks. The Beaufort branch opened in October 1865 and was followed by one in Charleston. According to General Scott, South Carolina freedmen

deposited almost $100,000 in 1866. Unfortunately, the Freedman's Bank went bankrupt in 1874.

A January 5, 1882 advertisement in the first issue of the *Palmetto Post* mentioned:

> *The Banking House of Wm. H. Lockwood, Bay Street, Beaufort, S.C. A general banking business transacted. Deposits received subject to check at sight. Foreign and Domestic exchange bought and sold. Collections made on any point in the United States. Real Estate bought and sold. Payment of Taxes a specialty…Also Agents for Rotterdam and Italian Lines of Steamers.*

In his paper on "Bay Street and Beaufort in the 1920s as I remember it," James G. Thomas stated:

> *In the early 20s there were two banks and one building and loan in Beaufort…Financially, July 10, 1926 was the climax. On that day, when after it* [Beaufort Bank] *had given a good financial statement, the bank failed to open, and from that day forward until 1939, Beaufort was in a decline. From 1939 to today, Beaufort has been advancing.*

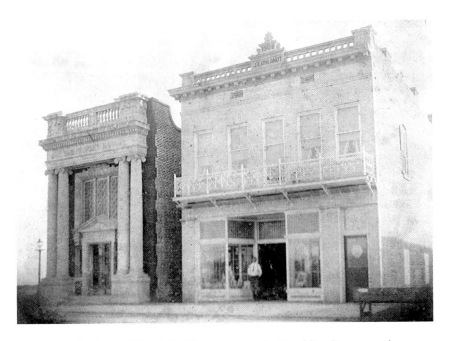

The Peoples Bank and Ohlandt Building on the south side of Bay Street near the corner of Carteret and Bay Streets.

THE MARSHES OF BAY STREET

The issue of ownership of marshlands and the control thereof can sometimes be an uncomfortable topic. In the late summer of 1973, the question of marshes came up in relation to Beaufort's downtown business area. Mayor Henry C. Chambers presented to the Beaufort City Council maps and documents showing that much of the fill since 1929 along the riverfront next to Bay Street was on property rightfully belonging to the City of Beaufort, granted to the city in the past by the general assembly of the State of South Carolina. There were other documents, as well, relating to waterfront property in the Bay Street business section. A Beaufort newspaper, *The Sea Islander*, reported:

> *It was enacted by the General Assembly of the State of South Carolina on March 4, 1929 that all marshes in tidal waters between high and low water mark lying in the North side of the Beaufort River, South of the City of Beaufort, and being West of Newcastle Street extended southward between high and low water mark in the South side of Beaufort River, North and East of the City of Beaufort between the Eastern end of Hancock Street, and the northernmost point of the City of Beaufort, commonly called Pigeon Point, be, and they are hereby granted to the Mayor and Councilmen of the City of Beaufort and their successors in office all intents and purposes as fully and completely and upon the same public uses and trusts as the same are now held by the State of South Carolina, with the right to reclaim same by dredging parts thereof for the creation of land areas for any public uses or purposes: Provided however, that no building higher than the level of Bay Street may be erected thereon nor shall any private rights or privileges by granted therein.*

CONCLUSION

Additional information on Bay Street, its houses and families, could well be obtained by searching the titles of properties, as far as those are available. Most of them can be traced back to 1865. Some older deeds were rerecorded in the Beaufort County Courthouse, and additional information may be in the files of Beaufort's older legal firms.

Bay Street is a living museum, which pictures the history of Beaufort, a Main Street, USA, showing not only the past and present, but also the promise of the future.

BEAUFORT'S NAME

Beaufort was so named to honor Henry Somerset, "Most noble Proprietor of the Province of Carolina in America," according to a pamphlet on Beaufort County government prepared by the League of Women Voters some years ago. However, there is more to the story—who were the dukes of Beaufort, why is the name pronounced different ways in the United States and why does Beaufort, South Carolina, seem to be unique in the way its inhabitants articulate their city.

Claude and Irene Neufer, in their book, *Correct Mispronunciations of Some South Carolina Names*, state the following:

> *Beaufort: BEU-fuht, BOE-fuht (first pronunciation in South Carolina; second pronunciation in North Carolina)…The Source of confusion for newcomers is that up the coast and across the state line the North Carolina town of Beaufort is pronounced BOE-fuht. Which is right? Both are.*

THE CORRECT PRONUNCIATION

This writer sought to explain how the differences in pronunciation arose in an earlier article written for the *Beaufort Gazette*.

> *Of all the places named Beaufort in the world, S.C. may be the only one pronounced "Bew-fort" instead of "Bo-fort." While both Beaufort, N.C. and Beaufort, S.C. are named for the same English 17ᵗʰ century nobleman, the accepted pronunciation for the South Carolina city is "Bew-fort" while that for the North Carolina one is "Bo-fort." A recent advertisement seeking an administrator for the Beaufort S.C. Main Street program even misspelled Beaufort as Buford.*

The answer is that while both Beauforts are derived from the same French word "beau" (meaning beautiful), the inhabitants of the North Carolina

town chose the modern French pronunciation "bo," while residents of the South Carolina town retained the medieval French sound "bew." The spelling remained the same.

The modern French "bo" sound is found in most words of French derivation. There is beau (a friend), beau geste, beau ideal, beaux arts (in the latter the "x" is pronounced "z"). The "bo" sound is retained in words like the Beaufort Scale (measure of wind velocity) and Beaujolais (a red wine), as well as in the city of Beaumont, Texas.

On the other hand, the medieval French pronunciation is retained in the word "beaut" (slang for beautiful) and the word beauty. It is also spoken thus for Beaulieu Plantation, near Savannah, Georgia, which is pronounced "Bew-lie."

David Frierson, writing in the *News & Courier*, gave another explanation for the difference in pronunciation in 1971:

> *Beaufort, North Carolina, was named after the same man, who, we are historically certain, called himself BYUFORT. Then why do they say BOHFORT? The most logical theory is that the early settlers recognized Beaufort as a French name, even though it belonged to an Englishman, and pronounced it after the French manner. Once it got started that way, it stuck.*

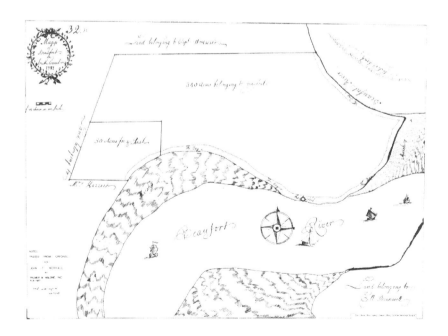

A 1721 map of Beaufort.

It is only the inhabitants of Beaufort, South Carolina, who continue to pronounce the name of their city as has been the manner since its founding in 1710, in the medieval French way, "Bew-fort," even though by 1710 most English-speaking people had switched to using the "bo" sound.

The old English poet Chaucer clearly foresaw the problem in 1385, when he wrote:

> *And for ther is so gret diversite*
> *In English and in writying of oure tonge.*

THE DUKES OF BEAUFORT

Mr. G.G. Dowling sent to the *Beaufort Gazette* a clipping from the *English Daily Telegraph*, a write-up of the life of the Duke of Beaufort who died early in February 1985. Dowling wrote:

> *As you know, our town was named for the 2nd Duke of Beaufort, and this Duke was the 9th…this County and County seat bear his ancestral name…Incidentally, the seat of the Duke of Beaufort is at Badminton, in Gloucestershire, and this is where the game of badminton also originated.*

The *Daily Telegraph* wrote that "a glowing reputation as 'the greatest foxhunter of our time'" was achieved by the Duke of Beaufort, who had died aged eighty-three.

> *For more than four decades he hunted several days a week with the green-coated Beaufort Hunt. Until he was 78 he was Master of the Horse to the Sovereign, serving three monarchs…His dedication to the sport made him the premier Master of Fox Hounds of England, surviving numerous falls broken bones…It pleased him to drive a car marked MFH1.*
>
> *The Duke came from a family of heredity foxhunters. The Beaufort Hunt and its fine pack were preeminent. For him fox hunting was the breath of life.*
>
> *He enjoyed riding over 52,000 acres on his Gloucestershire estate, until the M4 lopped Dauntsey Vale from hunt territory.*
>
> *Mounted fields of more than 200 would follow the Beaufort hounds. The hunt supporters' club had more than 2,000 members.*

> *The Duke said once: "Hunting is the only thing, which draws the country together, apart from war. Everybody takes part. Even the children are held up to see us pass"…If he were a fox, said the Duke, he would rather be hunted than die by any other method.*
>
> *Christened Henry Hugh Arthur RitzRoy Somerset, the Duke inherited the title of Baron Botecourt 1305, confirmed 1803, Baron Herbert of Ragland, Chepstow, and Gower 1506, Earl of Worcester 1514, and Marquess of Worcester 1642.*

The duke was described as a fine fisherman, a good shot and an amateur cricketer. He was honorary colonel of the Royal Gloucester and Bristol. In 1966, he was appointed chancellor of Bristol University and served four years.

ORIGIN OF THE BEAUFORT TITLE

The first Beauforts were three illegitimate sons (and one daughter) of John Gaunt by Catherine, widow of Sir Hugh Swynsford. The parents married in 1396 and Richard II declared the children legitimate the following year. The sons took their name "De Beaufort" from Beaufort Castle, in Anjou, France, where John and two brothers, Henry and Thomas, were born. John Beaufort, the first Duke of Somerset (1403–1444), was the one to which the letters patent of the title of Duke of Beaufort referred.

Henry Somerset (1629–1690) was made first Duke of Beaufort by letters patent, dated December 2, 1682, for

> *having been eminently serviceable to the king in his most happy restoration, in consideration thereof and of his most noble descent from King Henry Edward III by John de Beaufort, eldest son of John of Gaunt by Catherine Swynsford.*

The town of Beaufort, South Carolina, was named for his grandson, Henry Somerset, second Duke of Beaufort (1684–1714). The town of Beaufort, North Carolina, was also named for him. Born at Monmouth Castle, he held aloof from English politics until the collapse of the Whigs in 1710.

In April 1709, following the death of John, Lord Granville, he acquired a Proprietary share in Carolina. On January 17, 1711, the Lords Proprietors, answering the request of a number of merchants, gave "directions for

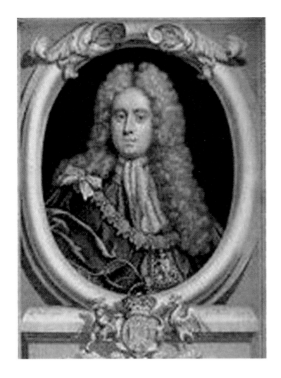

Henry Somerset, Second Duke of Beaufort, for whom Beaufort is named.

the building of a town to be called Beaufort Town" in honor of the new Proprietor, the Duke of Beaufort, "to be located on the Port Royal River on Port Royal Island." The Port Royal River was later renamed Beaufort River. It, too, is pronounced "Bew-fort."

Visit us at
www.historypress.net